sweet tooth

Exhibition
Catalogue

Sarah Tanguy

sweet tooth

COPIA The American Center for Wine, Food & the Arts

Napa, California

in association with Marquand Books, Inc.

Copyright Facts

Sweet Tooth is published by COPIA: The American Center for Wine, Food & the Arts in conjunction with the exhibition *Sweet Tooth* at COPIA, January 31 through May 12, 2003.

© 2002 COPIA: The American Center for Wine, Food & the Arts, 500 First Street, Napa, California 94559 and copyright holders as specified here. All rights reserved. No part of this publication may be reproduced without permission of the publisher.

Library of Congress Cataloging-in-Publication Data
Tanguy, Sarah.
 Sweet tooth / Sarah Tanguy.
 p. cm.
 Published in conjunction with the exhibition Sweet Tooth at COPIA, Jan. 23, 2003–Sept. 13, 2003.
 Includes bibliographical references.
 ISBN 0-9712643-1-7 (pbk. : alk. paper)
 1. Confectionery in art—Exhibitions.
 2. Art, Modern—20th century—Exhibitions.
 I. COPIA: American Center for Wine, Food, and the Arts. II. Title.
 N8217.C56 T36 2003
 704.9'4964186—dc21 2002151859

Available through
D.A.P./Distributed Art Publishers
155 Sixth Avenue, 2nd Floor
New York, New York 10013
Tel: (212) 627-1999 Fax: (212) 627-9484

Cover: Robert Arneson, *Blueberry Pie N°9*, 1971. See page 62

Back cover: Robert Watts, *Chocolate Cream Pie*, 1964. See page 112

Editor: Doreen Schmid
Designer: Jeff Wincapaw
Color separations by iocolor, Seattle
Produced by Marquand Books, Inc., Seattle
 www.marquand.com
Printed and bound by C & C Offset
 Printing Co., Ltd., Hong Kong

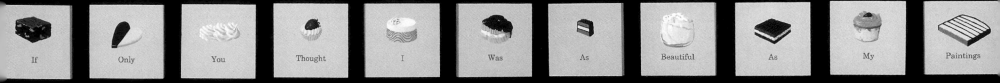

If Only You Thought I Was As Beautiful As My Paintings

Contains

Tempting, diverting, playful, and tasty—the artworks in *Sweet Tooth* entice us much as our favorite confections do. But as we gaze at Wayne Thiebaud's luscious renderings of dessert archetypes, Shimon Attie's lyrical and mystical sugar landscapes, Sandy Skoglund's inviting but unnerving fantasies, and Jana Sterbak's macabre chocolate bones, we quickly recognize that here is much more than eye candy—and most of us will experience a familiar ambivalence. We are alternately fascinated and repulsed by sweets, assigning them the status of both guilty pleasures and secret rewards.

Curator Sarah Tanguy has done a splendid job of selecting a group of artists and artworks that reveal the powerful symbolic role sweets play in contemporary life. Cake, candy, and other sugary temptations are a favorite source of gratification, and significant markers of social occasions. Paraded like celebrities, they are codas to our celebrations, centerpieces of cultural rituals, perhaps a reward for the risks of social engagement. The obvious candidates are Valentine's Day candy, wedding cakes, Halloween goodies, and the cakes brought to the grieving. Sometimes a favorite candy bar or breakfast treat can become a part of our own identity. Sweets are a favorite way we reward ourselves for small victories. Our vernacular is rife with idiomatic expressions that utilize the power of sweets, and speak to our deep-seated love/hate relationship with them. Whether we're proud chocoholics, secret indulgers or disciplined avoiders, sweets claim a significant part of almost everyone's mental landscape.

The forty artists Tanguy has assembled tackle these complex issues and many others with originality and passion. Far from being "sugar-coated," these works embody provocative commentaries on how we think about health, gender, self-image, addiction, and the ways commercial culture affects our interpretation of ourselves.

These artists are alchemists, transforming the commonplace into powerful works of art that surprise, disturb and delight us, often all at the same time. In some cases this transformation is literal, for many of the artists have used materials such as jelly beans, chocolate, and chewing gum as their medium. Such approaches are thoroughly contemporary yet also have strong links to the art of the past and the religious, social, and personal themes from which art has always drawn its nourishment.

In the chapters that follow, in Tanguy's essays about each artist, and in the way she has structured the exhibition, the aesthetic strategies these artists have employed in their work are illuminated, and our understanding of the lineage between the historical and the contemporary is enhanced.

Sweet Tooth is COPIA's fourth major exhibition. The quality of the show and the range of issues it raises are an apt articulation of COPIA's mission and a statement of our intention to continue presenting work that challenges, engages, and inspires. This is a feast for both the mind and the eye. These works do more than provide a momentary jolt of pleasure and a cargo of empty calories. They provoke thoughts and questions about pleasure and guilt, abundance and loss, and what does—and doesn't—make our lives truly sweet.

Introduction
Sarah Tanguy

What is it about sweets that keep us wanting more? Why is professing a sweet tooth a confession as much as a source of pride? Sweetness is one of life's most attractive pleasures. We crave its affirmation, lust after its flavor, and consume it in its various luxurious forms, as a reward, compensation, or peak sensual experience.

Most of us develop a close relationship to sweets as children and our tastes evolve over a lifetime. Artists too have fallen under their spell; acting as societal touchstones, they have the ability through their work to "fix" key developmental moments: happily sucking on our first lollipop, chewing our first piece of gum, biting into our first chocolate. Their visions awaken memories of birthdays, weddings, and other special occasions, stimulating our appetites with promises, albeit sometimes empty ones, of fulfillment and abundance. Some artists choose to address the darker side of sweets—issues of loss, marketing, gender, and disease—and engage in metaphysical speculation. They highlight an entire constellation of emotions involving self-image, guilt, and depression within both the public and private spheres.

Essentially, the works in *Sweet Tooth* are variations of the still life, an artistic expression featuring flowers, food, tableware, books, and symbols of learning. The term itself implies a contradiction. How can something be still and alive at the same time? How can something celebrate life even as it reminds us of death? *Sweet Tooth* explores this paradox on a variety of stages. In some cases the works themselves are literally perishable and subject to the effects of time. Other examples pulse with such naturalism that they initially trick the eye into believing the artifice. Yet other works bring to life ideas already present in our imagination.

A quick glance at the history of Western art affirms the still life's lasting power and vital signs. Some of the earliest examples are found in ancient Egyptian funerary art from the sixteenth through eleventh centuries BC, when sumptuous feasts were deemed essential for the well-being of the dead. Later, during the Greco-Roman period (particularly the first centuries BC and AD), secular paintings of food, called *xenia* or gifts to a guest, indicated plenitude and adorned the homes of the wealthy. The still life experienced a comeback in the Renaissance (the fourteenth through fifteenth centuries), when traces of Christian symbolism intermingled with Neoplatonist philosophy and an interest in the natural sciences. By the seventeenth century, the still life flourished all over Europe. Restrained odes to humble beauty countered extravagant depictions of luxurious excess, signaling worldly goods as well as the temporal nature of such possessions. It was not until the twentieth century, however, that the still life assumed new meaning for artists who sought to radicalize the very definition of art.

As contemporary artists revisit our most familiar obsessions and riff on seminal movements of the twentieth century, they use sweets to interpret current cultural practices. Rather than attempting a definitive inventory or advocating a particular position, *Sweet Tooth* emphasizes the modernization of concepts central to still life—mimesis, abundance, transience, and metaphor—pointing out multiple modalities and interconnections. We see how artists, experimenting with unconventional materials, engage in a magical transformation of the mundane, challenging rational expectations, underscoring our shared humanity, and inviting a renewed appreciation of life. For other than sex and death, what is more basic than food?

The story runs that Parrhasios and Zeuxis entered into competition, Zeuxis exhibiting a picture of some grapes, grapes so true to nature that the birds flew up to the wall of the stage to devour them. Parrhasios then displayed a picture of a linen curtain, realistic to such a degree that Zeuxis, elated by the verdict of the birds, cried out that now at last his rival must draw the curtain.

—PLINY THE ELDER, *NATURAL HISTORY*, XXXV, XXXXI.65

Material
Illusions

This chapter brings together artists who celebrate the sensual beauty of their subjects. In probing the interface between reality and illusion, they draw attention to the gap between what we apprehend through our senses and what we know to be true as we construct the authenticity of experience. Some, including Ed Ruscha and Meg Webster, experiment directly with sweets as raw materials. Ruscha, a painter, trained graphic designer, and innovative printmaker, has used black currant pie filling, Hershey's chocolate syrup, and other surprising substitutes in his iconic representations of the vernacular. With a nod to earlier monochromatic painting, Webster plays with the twin notions of transcendent purity and immediate gratification as she exploits the rich dark browns in her perishable molasses drawing.

In the hands of Wayne Thiebaud, Will Cotton, and Emily Eveleth, luxurious sweeps of paint parallel the icings and glazes of cakes, doughnuts, and lollipops. While their works don't try to persuade us that artifice is the real thing, they nonetheless prompt bodily appetites and slyly hint at sexual pleasure. Thiebaud's nostalgic displays of commercial sweets become formalist intricacies of line, shape, and color, their trademark halos reverently heralding the profane

glories of confectioned goods. First impressions of Eveleth's monumental portraits of dough-nuts may recall the spare compositions of Spanish still life paintings, but their scale and volup-tuousness, with cream oozing from suggestive orifices, overwhelm. Cotton creates his own Candy Land, where fantasies of gorging belie impending disaster. Chocolate falls, doughnut log cabins, and lollipop trees exuberantly unfold in his engaging panoramas based on elabo-rate sets and painted using Old Master techniques.

Peter Anton, Bruno Fazzolari, Matt Gray, and Alex Blau take the illusion even further. Their subjects are rendered with exacting precision, becoming self-referential icons ranging from the excessive to the bizarre. Mimesis, or imitation, lies at the heart of Anton's and Fazzolari's mixed media sculpture. Like the chocolatier at the court of Louis XVI whom they salute, Anton's superscale bonbons—some bearing unmistakable tooth marks—disarm with their over-the-top humor and penetrate the passions and yearnings of the beholder. More con-ceptual in approach, Fazzolari's dazzling floor installation of 961 cast-concrete cookies, each painted a slightly different shade of golden brown, plays with trompe l'oeil and the Minimalist

grid. Gray's series of photograms, titled *Stupid Candy,* assigns individual personalities to actual sweets. While some are instantly recognizable, others trigger a surreal dislocation through sheer weirdness. Blau's Chiclets-shaped paintings could easily pass as eye-dazzling abstractions. Yet their patterns and colors are often based on candy wrappers she finds on her travels and on the street. Reflecting different countries and ethnicities—such as the Mexican Heladitos, ice cream—flavored lollipops with bright pink, baby blue, white, and yellow packaging—the wrappers reinforce sweets' ubiquity and collective appeal.

Peter Anton

Born 1963, New Haven, Connecticut

Fit for a king! For all chocoholics Peter Anton creates mouth-watering bonbons, so large and so real that fantasies take all sorts of wild and unexpected journeys. With engaging titles such as *Dream Assortment* or *King Size,* Anton's colorful, seductive sculptures conjure guilt-free satisfaction and happy memories. But they also explore indulgence, obsession, and forced consumption. While most candies are left pristine, others are ravaged, showing evidence of being bitten or pinched to reveal tantalizing centers of creams, nuts, jellies, and caramels. A few are entirely consumed except for rejected bits or empty wrappers.

Anton's research on historical precedents has chronicled one Aztec emperor's daily habit of drinking fifty goblets of cocoa and Louis XIV's creation of the official court position of "Chocolate Maker to the King." The artist himself cannot resist the charm of his sampler boxes, often posing alongside in a full eighteenth-century dandy's costume, mysterious priestly garb, or other unlikely guises, exaggerating the sense of contradictory scale and playful humor.

Anton began sculpting snack foods in the late eighties and a few years later started making everyday fruits and vegetables. He turned to sweets when dealers scoffed at his oversize produce. Each of his meticulously crafted simulacra reflects a unique labor of love using a wire armature in lieu of a mold and various materials including clay, resin, and paint. Art lovers can also find delight in his deft trompe l'oeil effects and clever riffs on the Minimalist grid and Claes Oldenburg's Pop aesthetic.

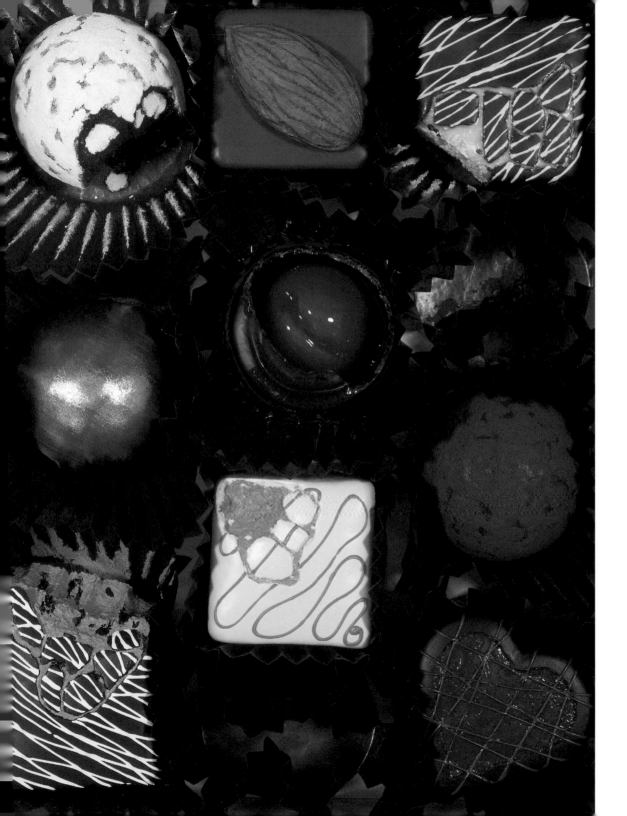

Monarch Assortment, 2000
Mixed media
48 × 36 × 10 inches
Loan courtesy Gracie Mansion Gallery,
New York, NY

Alexandra Blau

Born 1970, Austin, Texas

Choco, 2001
Acrylic on linen
12½ × 12½ inches

Fruit Stripe, 2002
Acrylic on linen
12½ × 12½ inches
Loan courtesy Mark Moore Gallery,
Santa Monica, CA

Alexandra Blau's glossy paintings confound the boundaries between abstraction and representation and between high and low art, even as they bridge the gap between life on the street and work in the studio. The signature oblong shape of these paintings with rounded corners, which brings to mind oversize mints or Chiclets gum, endows the work with a pronounced sculptural presence. As do holiday candies, the bold patterns and bright palette of these pieces keep the eye and memory pleasantly engaged, yet they also remind us that those candies are not much more than "empty calories."

Surprisingly, their patterns are actually inspired by snack or junk food wrappers. During graduate school, the artist developed a fascination with commercial food packaging and signage. She began randomly collecting wrappers and photographing advertising signs, often while driving her car. More than addressing issues related to recycling and consumption, the packaging informing her current work reflects her trips to different parts of the United States and other countries as well as the broad range in ethnicity of the greater New York area (Blau resides in Brooklyn). From a distance the paintings appear opaque and machine-produced. Up close, however, they faithfully record Blau's hand and her abiding commitment to process. Layers of airbrushed designs, painstakingly controlled by masking tape and sandwiched between clear gloss, result in transparent webs. While their depth reveals the artist's struggle in creating them, their optical effects mesmerize much as candies and their packaging exert a mindless gravitational pull on the consumer.

Blau's paintings interpret and synthesize seemingly opposing twentieth-century art movements. Drawing on Cubism's use of collage and Pop Art's iconography, she pares down commercial designs, employing a jigsaw effect reminiscent of the universal dynamism in Piet Mondrian's abstract paintings. Rather than conveying utopian aspiration or social critique, her paintings are celebratory and immediately accessible. They speak of our shared humanity and feel very close to home.

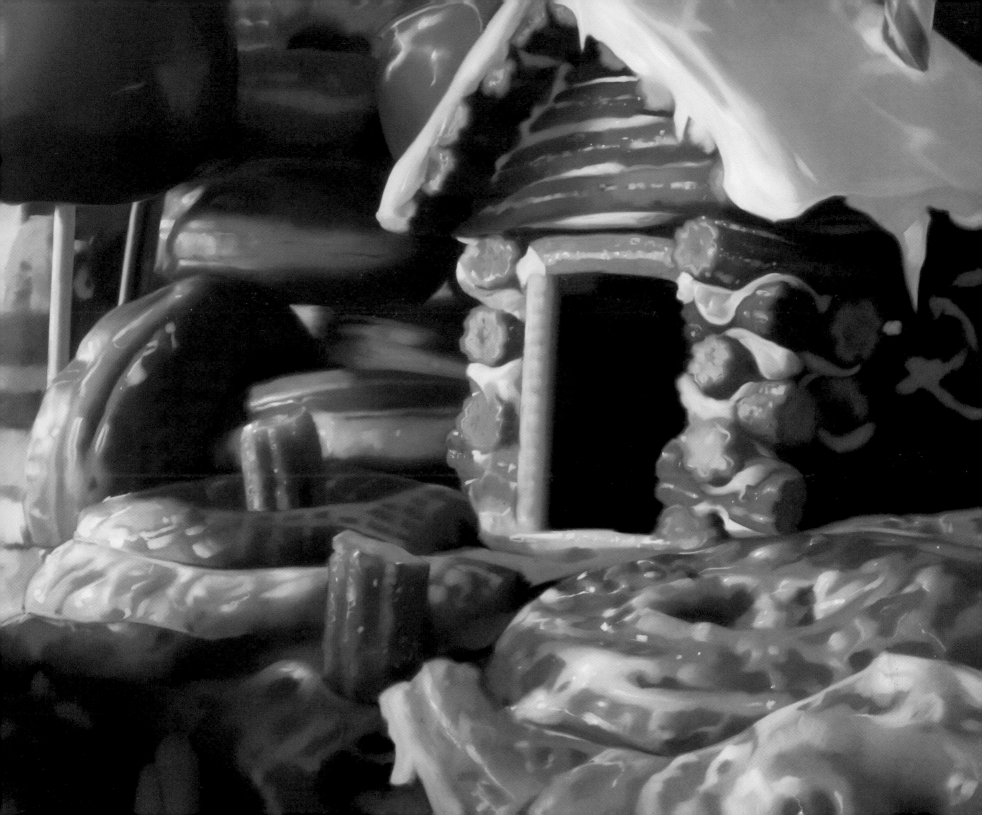

Will Cotton

Born 1965, Melrose, Massachusetts

Abandoned (Churro Cabin), detail, 2002
Oil on linen
60 × 60 inches
Loan courtesy Mary Boone Gallery,
New York, NY

Mouth-watering panoramas of indulgence and bounty, Will Cotton's paintings of chocolate falls, doughnut log cabins, and lollipop trees are also roadmaps for adventure. Recalling the virtuoso theatrics and emotional impact of Baroque religious painting, they awaken sensual appetites and dispel any antiquated notions of puritanical reserve.

Fond memories of Candy Land, a fifties board game, became the catalyst for Cotton's vision and a challenge to his artistic skill. His working process typically begins with the construction of an elaborate set incorporating real confections. Using cinematic techniques, he then photographs the dioramas and, with the aid of a little computer wizardry, creates images that serve as the basis for his monumental paintings. Light caresses the myriad nooks and crannies, while paint lovingly interprets luscious sweeps and globs of icing, congealed and molten pools of sauce, or sticky traps of sugar glazes, minus the cool detachment of Photo-Realism or the mock empathy of Pop Art.

Buried underneath the delectable surfaces pulse shared memories and ambivalent testimonies. *Kiss Me,* featuring a Valentine's Day lollipop in a frosted rose garden, pokes gentle fun at sentimental love. By contrast, *Flooded* depicts a sugary sweet pink house being swept by a lavalike flow of equally pink icing. In *Abandoned (Churro Cabin),* a common Mexican pastry becomes the building block of a log cabin. A perfect image of fusion culture, the house blends nostalgia for the American frontier and Germanic fairytales with the culinary taste of Mexico. At the same time, the work implies an ambiguous narrative with ominous overtones. Why is the door ajar? Where are the people?

In the artist's discourse between illusion and reality, artifice wins, transporting the willing viewer to virtually plausible, private realms of sex and desire. Even as they promise abundance, however, Cotton's luscious paintings warn of never having enough.

Emily Eveleth

Born 1960, Hartford, Connecticut

On a spare stage infused with a soft golden light, two monumental doughnuts nudge each other as thick purple jelly oozes from suggestive fissures. Their bulging fleshy bodies push up so close to the picture plane that you think their sticky surfaces might actually brush your face. You start salivating in anticipation and surrender to their charm.

Up close, Emily Eveleth's cream-filled, powdered, or honey-glazed doughnuts dissolve into lush passages of painterly abstraction. Shunning the brassiness of Pop icons, their idealized presence and meticulous compositions recall instead Renaissance and Baroque painting. Trained as a landscape painter, Eveleth turned her disciplined and sensual eye to still life nearly a decade ago. One day, after taking stock of a doughnut sitting on her kitchen table and marveling at the beauty and perfection of its form, she embarked on making small-scale studies of this banal confection. By 1992 the works had significantly increased in scale. More recent paintings depict the backs of men's heads looming silently against dark, ominous backgrounds. Anonymous and objectified, they appear to reverse the anthropomorphic and portraitist qualities of the doughnuts.

Endowing still life with new vigor and passion, Eveleth's bold brush strokes and tactile surfaces recall those of a Rubens painting, while her dramatic chiaroscuro and humble content suggest the work of Caravaggio. As the artist maintains the integrity and independence of her subjects, she celebrates the sheer pleasure of paint and its seductive application.

Approach, 1998
Oil on canvas
60 × 66 inches
Private Collection; courtesy
Danese Gallery, New York, NY

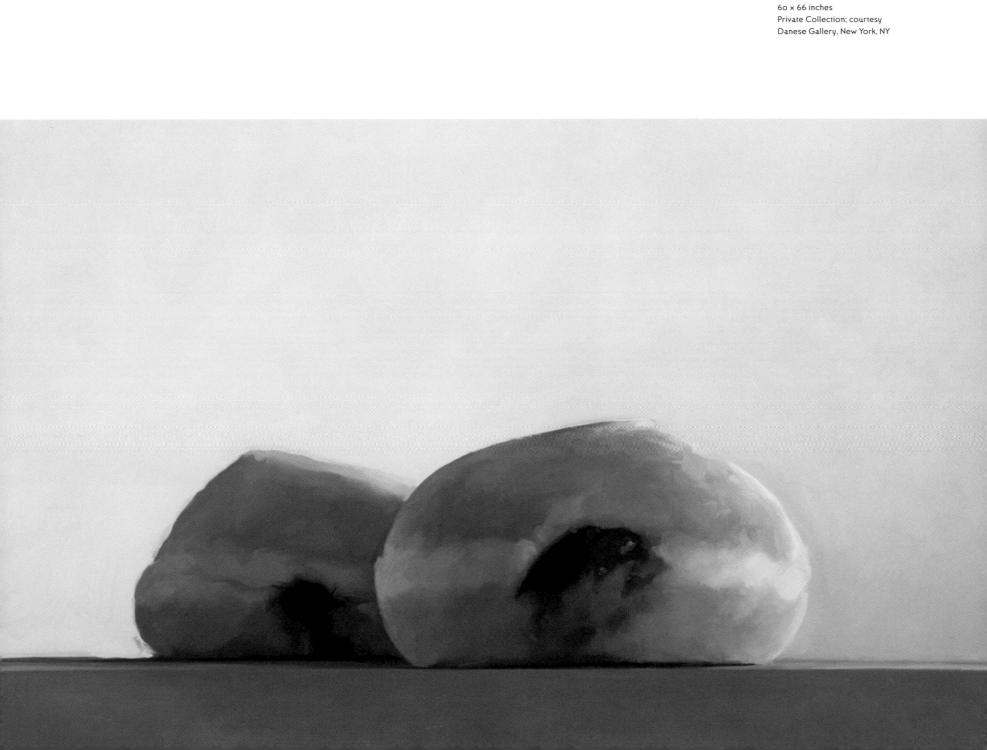

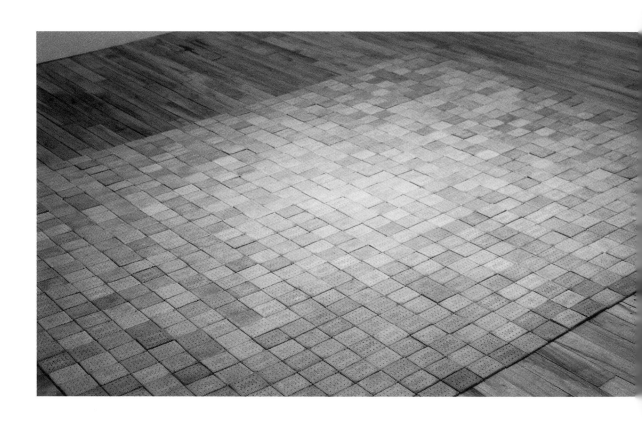

Leibniz, 1998–2000
Plaster, oil paint
961 pieces, 62 × 77 inches
Loan courtesy Debs & Co., New York, NY

Bruno Fazzolari

Born 1967, Mexico City, Mexico

That G. W. Leibniz, a leading thinker during the Enlightenment and the inventor of differential and integral calculus, could inspire a work of contemporary art may seem far-fetched, but not for Bruno Fazzolari.

The seventeenth-century philosopher posited a preestablished, harmonious universe composed of an infinite number of individual and indivisible units or monads, each of which reflects the others perfectly. Fazzolari's *Leibniz,* a floor installation of 961 variously hand-painted plaster replicas of the popular German butter cookie, both honors and parodies Leibniz's theory. With a nod to Carl Andre and the Minimalist grid, the work dazzles us with its golden beauty and formal perfection while spoofing our current fascination with mass-produced gourmet food.

Like much of Fazzolari's other food-related painting and sculpture, *Leibniz*'s faux naturalism plays with viewer expectations. While something looks real and appetizing from a distance, up close a slight distortion is noticeable and the illusion falls apart. In some cases, such as his painted plaster and polymer clay sausages and molded cauliflower, curiosity turns into disgust. The artist's fascination with food stems in part from trying to reconcile his mother's sophisticated culinary sense with the more prosaic tastes of his Arizona childhood. He also is interested in the paradoxical elements of haute cuisine, where culture and nature jockey for control. The artist often presents a cross-media study of a subject, such as *Grosse Brioche à Tête,* which combines a hand-bound replica of a brioche cookbook, a group of trompe l'oeil sculpted brioches, and a gelatin silver print of the actual pastry.

Fazzolori's work, including his oversize, creamy chunk of Camembert entitled *C-Bert,* couples a Pop attitude toward consumer culture with a more mysterious approach to surface and skin, much like Cy Twombly's manipulated found object sculpture. This intriguing and tantalizing combination explores perception and the multiple ways to experience the unexpected richness of the mundane.

Matt Gray

Born 1969, Baltimore, Maryland

Candy is such a part of our lives, whether consumed alone or on social occasions, that the title *Stupid Candy* almost seems like a cruel or thoughtless dismissal. This was not Matt Gray's intention. He had just completed an exhausting three-year project involving cinematically produced "photo tableaux," in which people were requested to enact scenarios of their choice—no matter how outrageous or strange—based on newspaper ads. The final installation, titled *Spit (white boy paranoia narrative)* and featuring roughly 130 thirty-by-thirty-inch photographs, is a kind of hallucinatory visual overload.

The *Stupid Candy* series became a means of decompression, of exploring images that celebrated pleasure and comfort. Unlike the elaborate sets in *Spit,* the *Stupid Candy* images are photograms made in the darkroom by placing actual objects, rather than film, in the enlarger. As unique expressions possessing an ethereal beauty, they contrast with their mass-produced subjects and enthrall with individual nuances in architecture, palette, and luminosity. At the same time, these singular portraits are curiously anonymous. Bereft of their brand packaging, the objects assume various allusions to shovels, mirrors, rings, and creepy humanoids. Rather than conveying Pop rhetoric, critical theory, or social critique, however, their attention to surface represents an engrossing fusion of the readymade and the spectacle.

Other liberating ventures by Gray include *Two White Rabbits,* enlarged close-ups of rabbits that, removed from any recognizable context, read as textured variations of pink and white. As grotesque as a sci-fi creature, *My Right Eye,* a hyperreal view of the organ on a low shelf against a sky-blue background, alludes to medieval experimentation. Again these photographs resist analysis, appealing instead to the imagination and curiosity. In all of his endeavors the artist tests the notion of psychic distance, the degree to which a subject is removed from reality in relation to the psychological impact on the viewer. Ironically, it appears that the less removed his subject, the more fantastical the results.

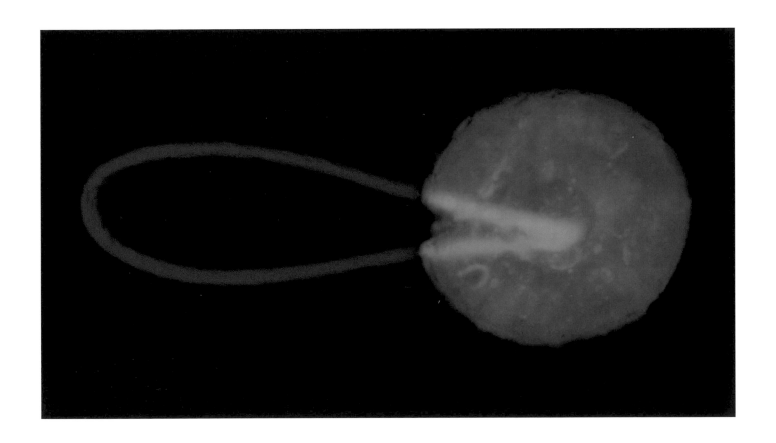

Untitled (N° 3920, *Stupid Candy* series), 2000
C-print
20 × 24 inches
Loan courtesy Richard Levy Gallery,
Albuquerque, NM

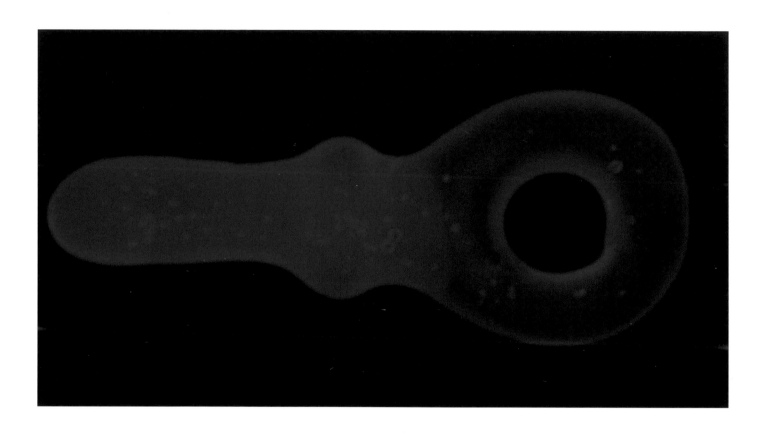

Untitled (Nº4301, *Stupid Candy* series), 2001
C-print
20 × 24 inches
Loan courtesy Richard Levy Gallery,
Albuquerque, NM

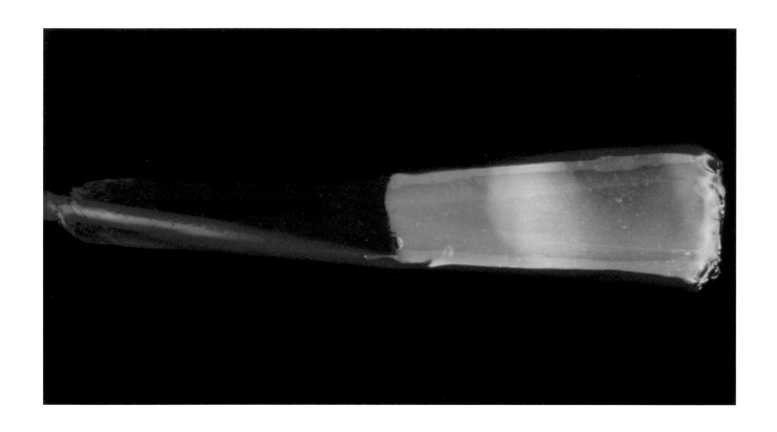

Untitled (Nº 3925, *Stupid Candy* series), 2000
C-print
20 × 24 inches
Loan courtesy Richard Levy Gallery,
Albuquerque, NM

Ed Ruscha

Born 1937, Omaha, Nebraska

Proof for *Sweets, Meats, Sheets,* from
the *Tropical Fish* series, 1975
Color screenprint, E. 83
32¾ × 25¾ inches
Loan courtesy Fine Arts Museums of
San Francisco/Achenbach Foundation
for Graphic Arts, Museum Purchase,
Mrs. Paul L. Wattis Fund, 2000.131.72

With a chameleon-like ease and relentless curiosity, Ed Ruscha has excavated the look and language of popular culture and the Western landscape for decades. Reflecting his training in both commercial and fine arts, a strong graphic presence combined with an ironic detachment and a documentary sensibility marks his artist books, paintings, prints, photographs, films, and drawings, where words or their implied presence often become the primary subject.

An early work such as *Standard Station, Amarillo, Texas* demonstrates this passion for the view from the road, its signs, and its architecture. The sleek rendering of a gas station boasts cinematic drama while its oblique perspective and crisp reductionism evokes the style of the Precisionists. He is also known for his non-narrative photographic artist books, which he considers among his most important contributions to the art world. Bound in blue felt with pink ribbon, one of these books, *Babycakes,* wittily juxtaposes a picture of Ruscha's son at birth and images of various sweets with their corresponding weights. Other landmarks in his career include *Liquid Word, Stains, Silhouette,* and, more recently, illusionistic images of snowy mountains and aerial streetscapes entitled *Metro Plots.*

Equally innovative are his experiments with materials—including fruit and vegetable dyes, axle grease, chocolate, and gunpowder—and support. At times he has substituted sandpaper and wood veneer for paper or used satin, moiré, and crepe fabric for canvas. This exploration caused a sensation in his *Chocolate Room* at the 1970 Venice Biennale, where 360 sheets of paper screenprinted with aromatic chocolate lined the walls like shingles, creating a mouth-watering environment. Somewhat more detached and emblematic but no less effective is his silk-screen series *News, Mews, Pews, Brews, Stews & Dues.*

For over forty years, Ruscha has switched between media, styles, and movements, emerging as a vital independent voice and influence in contemporary art. Incorporating the logos and effects of our movie- and media-obsessed culture, he stresses discontinuity between image and text and between subject and its realization. His banal glamour redefines the heroics of earlier movements such as Abstract Expressionism and the Hudson River School into a sublimely deadpan manifesto, full of enigma but rooted in a street sensibility.

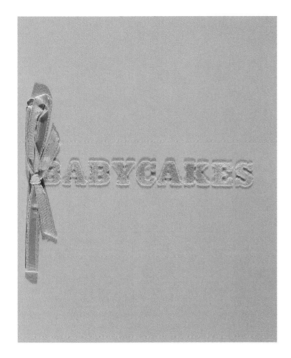

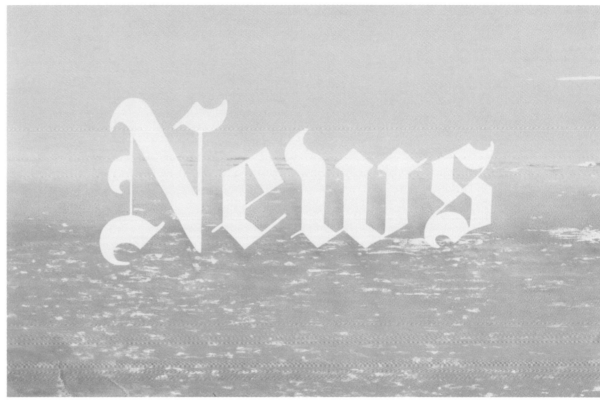

Babycakes with Weights (New York:
Multiples, Inc., 1970), 1970.
Cover of 52-page book with 22 b&w
offset prints
7½ × 6¼ inches closed
Loan courtesy Fine Arts Museums of
San Francisco/Achenbach Foundation
for Graphic Arts, Museum Purchase,
Reva and David Logan Collection of
Illustrated Books, Reva and David Logan
Fund, 2001.64.2.1–22

News, from the portfolio *News, Mews,
Pews, Brews, Stews & Dues*, 1970
Color screenprint printed with black
currant pie filling and red salmon roe,
E. 34
25 × 31 inches
Loan courtesy Fine Arts Museums of
San Francisco/Achenbach Foundation
for Graphic Arts, Museum Purchase,
Mrs. Paul L. Wattis Fund, 2000.131.34.1

Wayne Thiebaud

Born 1920, Mesa, Arizona

Wayne Thiebaud's unforgettable odes to baked goods and consumer commodities represent the American ideal of bounty par excellence. At times bordering on hedonism, the sensual attraction of his subjects and brushwork is exquisitely balanced by tightly controlled compositions.

Before devoting himself fully to art, Thiebaud was a cartoonist, poster designer, commercial artist, and Disney animator, professions in which he honed a knack for exaggerating pattern and distilling form. By the early sixties he had developed his signature style, which combines visceral brushwork reminiscent of Abstract Expressionism with a classic formalism and the kind of silent hush found in the paintings of Chardin and Morandi. What makes his figurative works, landscapes, and urban scenes so distinctive, however, is an intense raking light inspired by northern California as well as a bright palette and a tilted perspective.

Taken from his imagination and memory, Thiebaud's subjects speak of his middle-class childhood and fond recollections of family picnics, bakery displays, and toy counters, conveying a sense of nostalgia that triggers the viewer's longing. Like a baker's icing-smeared spatula, the artist's paint-loaded brushes caress the canvas and coax his delectables into shape. In *Two Heart Cakes,* the nearly identical forms are built up through pastel bands and tilted forward to better entice the viewer. Blue semicircular shadows animate the open, abstract backdrop, which curiously calls to mind a sandy beach. The creamy textures beg you to lick the surface and run your hand over the painting's heart pattern.

Thiebaud's cherished selection of carefully arranged objects parallels our need for romance and consumable goods, while his pleasure in painting brings our own desire and imagination to life. Void of irony or critique, his enticing fetishes cheerfully celebrate the senses and optimistically offer a promise of renewal.

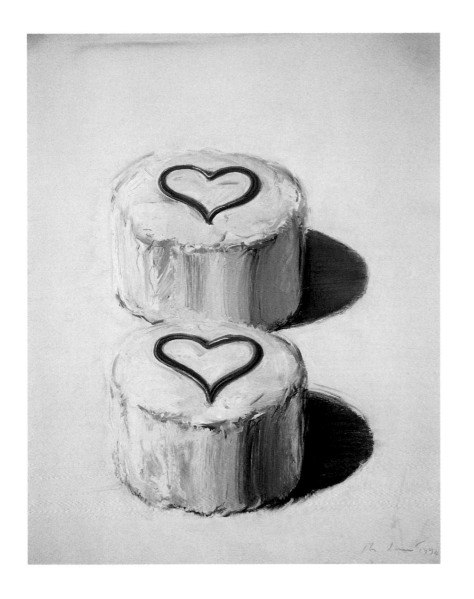

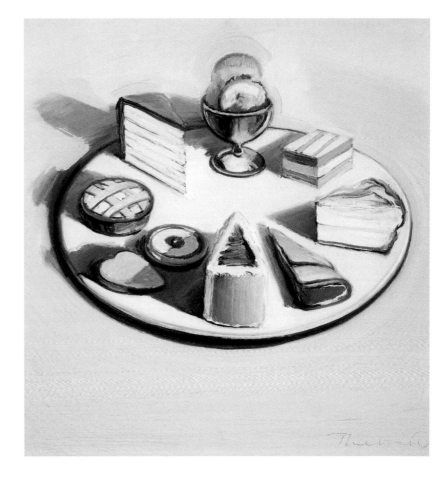

Two Heart Cakes, 1994
Oil on linen
28 × 22 inches
Loan courtesy LeBaron's Fine Art,
Sacramento, CA

Dessert Circle, 1992–1994
Oil on panel
21 × 19 inches
Loan courtesy Betty Jean
Thiebaud

Meg Webster

Born 1944, San Francisco, California

Long known for her earth-based installations, Meg Webster has also applied her interest in organic materials to food-related art. Both bodies of work share a utopian vision infused with empirical curiosity and grounded in sensual phenomenology.

Webster began as a painter and switched to sculpture in the seventies. Some of her early experiments involved cones of salt and spheres and mounds of earth, not to mention the outdoor *Kitchen Garden. Circuit Offerings,* which featured a wooden table laden with fruits, nuts, and vegetables for viewers to sample, was one of her first installations to bring nature inside the gallery and interact directly with the audience. In her more recent *Blue Sky,* viewers traverse a barren pile of huge boulders and then enter a second gallery to experience a grouping of clear glass orbs on the floor and a video of a gushing waterfall complemented by two other videos of a lamb being born and a sheep being shorn. This enigmatic, yin-yang presentation alludes to the various life cycles of the planet, be they animal or geological.

The idea of cyclical time pulses through works incorporating food substances such as chocolate, eggs, and butter. *Molasses* is a luxurious, monochromatic, and living expanse whose square format and unconventional material blend aspects of Post-Minimalism and late Modernism while recalling Ed Ruscha's experiments with food. A sense of bounteous beauty, barely contained by the parameters of the paper support, counterpoints a visceral arousal of sight and smell that triggers private memories and anticipated fulfillment.

Using natural ingredients as subject and material, Webster's endeavors present mesmerizing discoveries. While reflecting a desire to make connections with the ecosystem of the planet, they touch the sensibility and intellect of the audience.

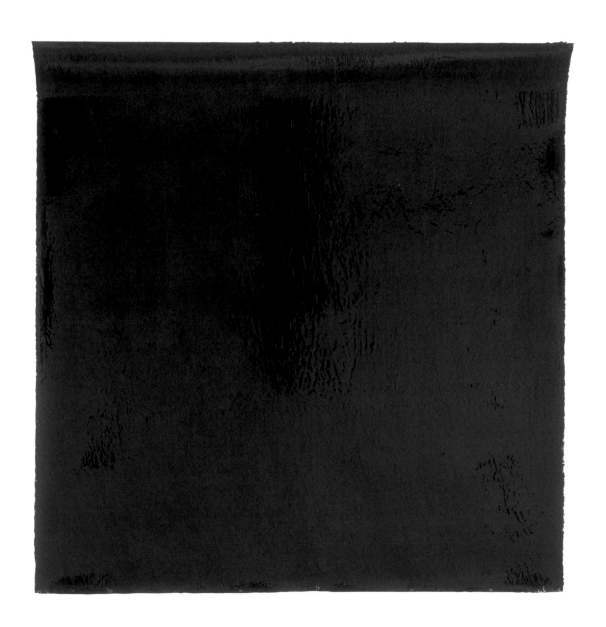

Molasses, 2002
Molasses on paper
60 × 60 inches
Loan courtesy Paula Cooper Gallery,
New York, NY

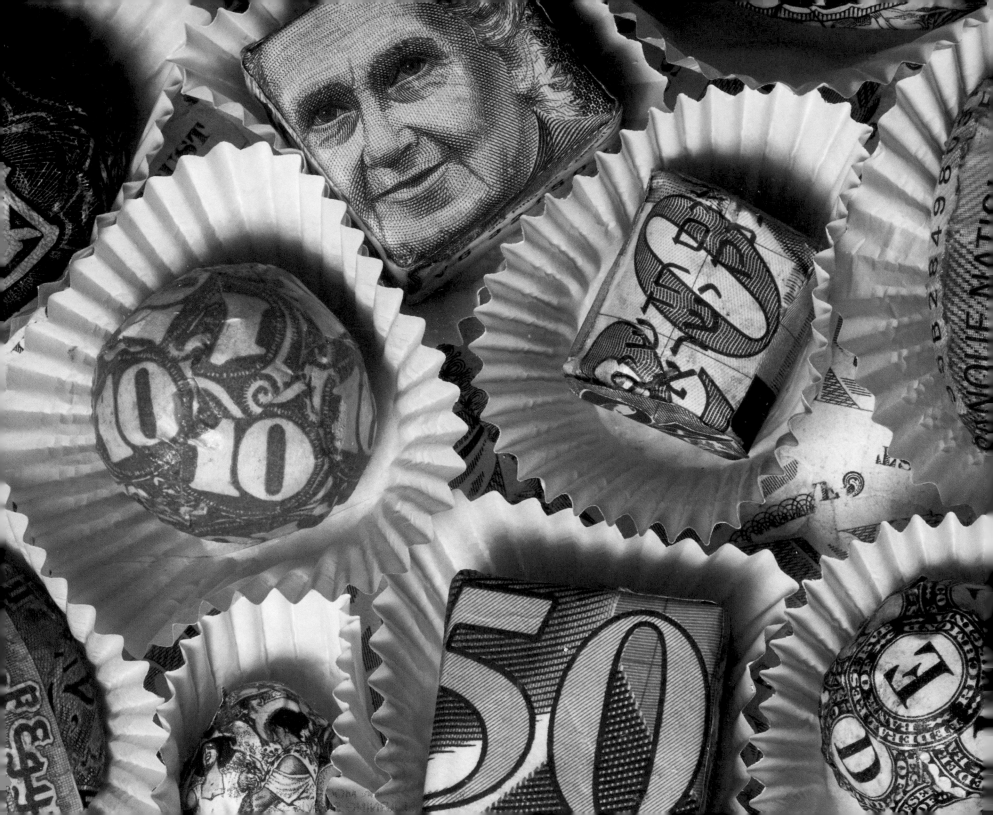

Loss and
Transience

The works in this chapter remind us of the fleeting nature of existence. In Baroque still lifes, artists commonly included skulls or timepieces in their compositions. Value-laden, this type of still life, known as *vanitas*, exposes the folly of unbridled desire. It encourages moderation and an appreciation of the things we take for granted, including our time on earth. In this context, using sweets becomes subversive—"a spoonful of sugar helps the medicine go down . . ."

By exploring process, Jana Sterbak and Vik Muniz generate enigmatic imagery that feeds on perishable and volatile materials. Sterbak's *Catacombs,* chocolate replicas of human bones, shatters one of our most anticipated pleasures. Like her other idea-driven work, this unnerving installation elicits an intense visual and cognitive dissonance in associating something highly desirable with the certainty of death. Muniz, on the other hand, deploys a more mediated or layered strategy. In his *Pictures of Chocolate* series, he re-creates well-known images from the annals of history by photographing congealed threads and blobs of chocolate syrup. Other series use dust, sewing thread, or recycled cigarette butts to overturn expectations and trigger new ways of seeing.

Shimon Attie, Enrique Chagoya, and Barton Lidice Benes mine the slippage between health and disease with Attie and Chagoya taking on the substance of sugar (glucose), a common and popular source of fuel. In Attie's *White Nights, Sugar Dreams* series, inspired by the artist's experience with diabetes, he plays with our sense of beauty and repulsion by juxtaposing crystals of sugar with drops of blood, morphing them into surreal landscapes or lyrical abstractions. Chagoya's approach is more narrative and includes a dose of humor. His drawings for the bilingual children's book *Mr. Sugar Comes to Town* chronicle the protagonist's popularity when he offers ice cream cones and other goodies to children, who first experience elation and then crash from the sugar high. Later on, they depict Mr. Sugar's fall from favor when a grandmother rips his mask off and restores healthy eating habits. In Benes's jarring double take *Petits Fours*, a bright array of delicacies turns out to be nothing other than AIDS cocktail pills.

Money and fame also inspire *vanitas* imagery, since their pursuit leaves the appetite equally dissatisfied. Benes, known for his *Reliquaries*, souvenirs featuring celebrity discards, makes the candy wrappers in *Sampler* from actual bills of various countries, including some discontinued

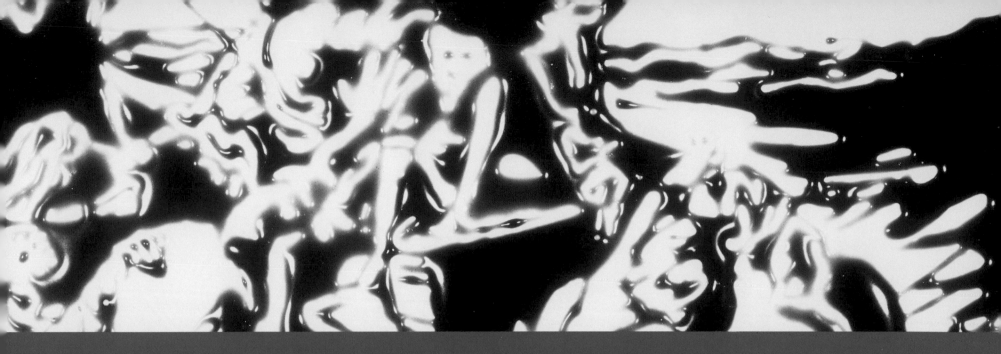

currencies. The chocolate bonbon box is reconfigured in Mildred Howard's shocking testimonials to slain rappers, in which candy wrappers display photo-screened images of the deceased's face and bullets or contain tiny bones and teeth. Highlighting racial and class associations, the work also recalls African medicine bundles or miniature coffins. Meredith Allen's creepy photographs of cartoon celebrity Popsicles melting against lush landscapes contrast the beauteous handwork of nature with the manipulative appeal of manufactured items.

The notion of shelf life leads to a more metaphysical treatment of the passage of time for Rebeca Bollinger and Ted Victoria. In Victoria's low-tech photo installations using the camera obscura, live Sea-Monkeys perform a dance macabre in a nostalgic scene of an outdoor picnic interrupted by pests. Bollinger trolls the Internet for portraits of children posted on home pages of actual websites as her source material. Then, using a "Sweet Art" machine that works like an ink-jet printer, she transfers the images onto baked cookies. In these troubling confections, hints of cannibalism help create a sense of loss and horror: How could anyone eat an innocent child?

Meredith Allen

Born 1964, Bangor, Maine

Enthralled by the idyllic wilderness of Long Island's coast in summer, Meredith Allen wanted to photograph pretty landscapes yet avoid cliché. The solution occurred in 1999, when one of her nieces asked for a Popsicle and chose one that looked like Tweety Bird. Pitting two objects of desire against each other with the artist as intermediary, the *Melting Ice Pop* series features various Saturday morning cartoon characters melting against scenic views. Taken with a point and shoot camera, the images counterpoint a fuzzy landscape and a hyper-focused, in-your-face dessert, with the photographer's supporting hand acting as an irritating stop sign.

An uncanny tension results from contrasting nature and culture, beauty and the grotesque, attraction and repulsion. Sickly-sweet flavors become garish colors producing painterly effects when the flash picks up the dripping ice cream. This process of disintegration allows Allen to explore our ability to identify a character with only a few cues while reminding us of the fleeting nature of fame. As their smiles turn slowly into macabre grins, the cartoon stars seem to beg us to end their suffering by indulging in the sensual yet cannibalistic acts of licking and biting. This anticipated pleasure, heightened by the contrast between her fleshy hand and the gooey ice cream, is made even more poignant by the knowledge that the Popsicles will eventually share the fate of Icarus and be melted by the sun's rays.

Allen's early ventures into food included a series of photographs, created in graduate school, that juxta-posed produce rotting on the windowsill with excerpts from Harlequin romance novels. Her love of iconic, decaying imagery is also the focus of a series on kiddy-ride animals, which initially featured their portraits and later more abstracted blowups of their tails. With humor, intelligence, and a tinge of nostalgia, Allen spotlights the empty calories of our consumer culture and celebrity worship, creating memento mori out of everyday items and household names.

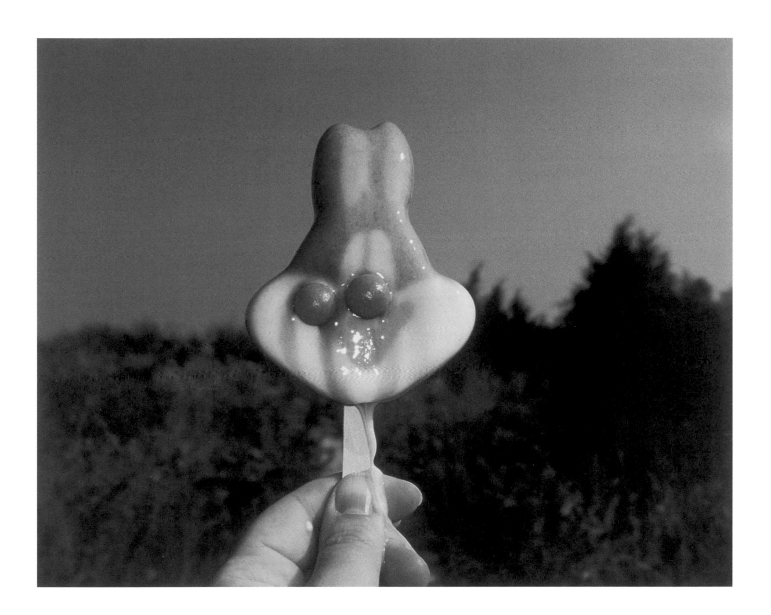

Atlantic Avenue (bugs bunny), 2000
C-print
18 × 22 inches
Loan courtesy Gracie Mansion Gallery,
New York, NY

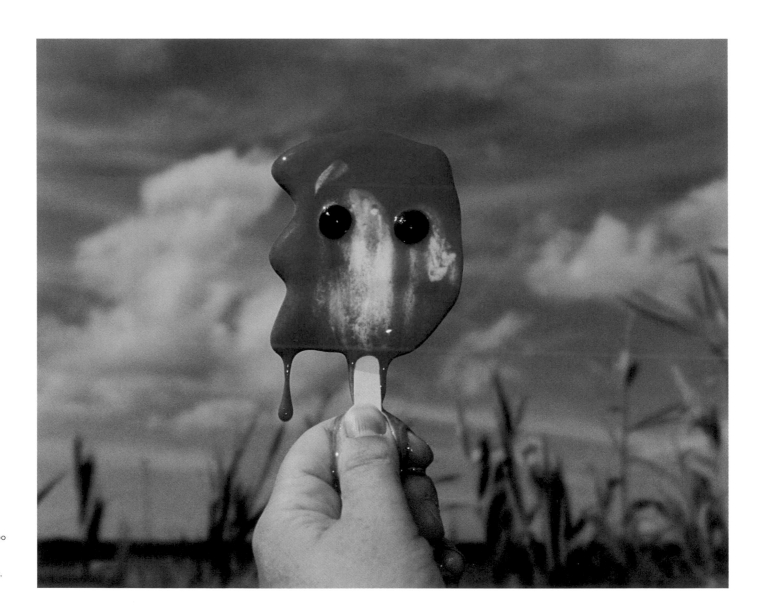

Moriches Island Road (supersonic), 2000
C-print
18 × 22 inches
Loan courtesy Gracie Mansion Gallery,
New York, NY

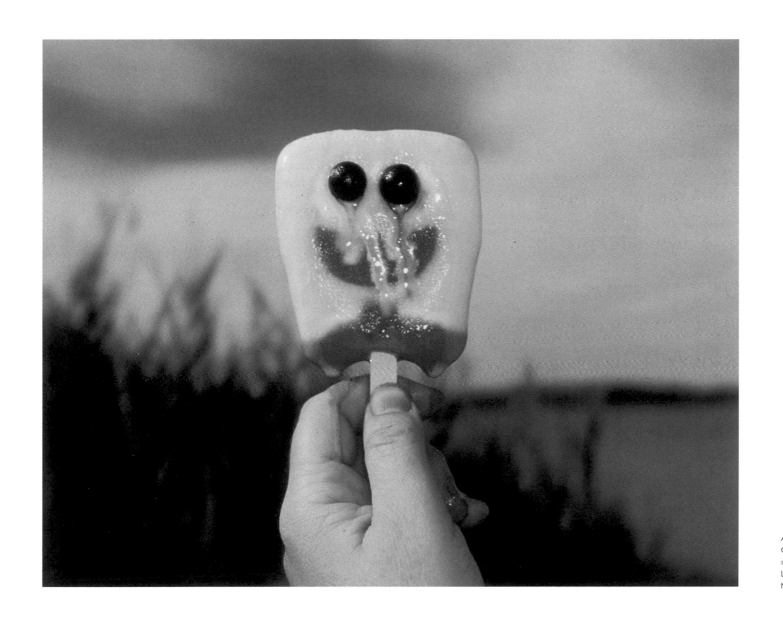

Atlantic Avenue (spongebob), 2001
C-print
18 × 22 inches
Loan courtesy Gracie Mansion Gallery,
New York, NY

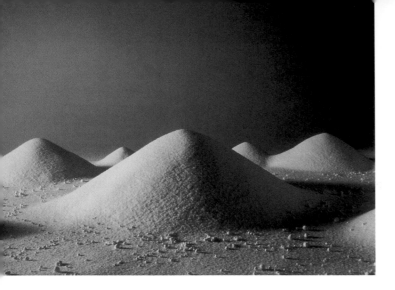

White Night, Sugar Dreams Nº3, 2000
Chromogenic print
30 × 40 inches
Loan courtesy Gallery Paule Anglim,
San Francisco, CA and the artist

White Night, Sugar Dreams Nº4, 2000
Chromogenic print
30 × 38 inches
Loan courtesy Gallery Paule Anglim,
San Francisco, CA and the artist

Shimon Attie

Born 1957, Los Angeles, California

Life and death, safety and danger, balance and chaos, nutrition and poison—these are the subjects of Shimon Attie's daunting and provocative work. In *White Nights, Sugar Dreams,* the artist's personal history with diabetes becomes an open-ended, abstract meditation on redemption. The series grew out of a 2000 residency sponsored by Providence Public Library in Rhode Island, where he interviewed fellow diabetics and collaborated with students from Rhode Island School of Design.

Sugar and blood are equally needed to sustain life, but for a diabetic, regulating their ever-fluctuating interdependence is a difficult task at best. Rather than passing judgment, the artist's video installation and accompanying color photographs replace the banal physicality and conventional views of these two substances with images of great and wondrous beauty. They take the viewer on a surreal journey in which lush destinations are simultaneously familiar and alien. Some images show sugar crystals snowing, cascading, or forming sensual dunes that evoke the sub-Saharan desert or the moon's surface, while others create a pointillist interplay between blood drops and sugar particles or even suggest faces. In the video, the words *bitter, sour,* and *salty* are shouted obsessively, leaving the appetite unfulfilled. Yet, in spite of their irresistible appeal, the images' implied deadly warning cannot be overlooked.

A trained psychologist, Attie is known for his photo-based, figurative public art projects, which excavate and redeem collective memory as he explores such topics as the history of the Holocaust and the demographic changes in New York's Lower East Side. Mixing formal discipline with highly charged content, he orchestrates haunting metaphors for personal struggle and loss of freedom. Infused with a sense of healing, these works transcend their topicality and assume an ethereal, monumental quality.

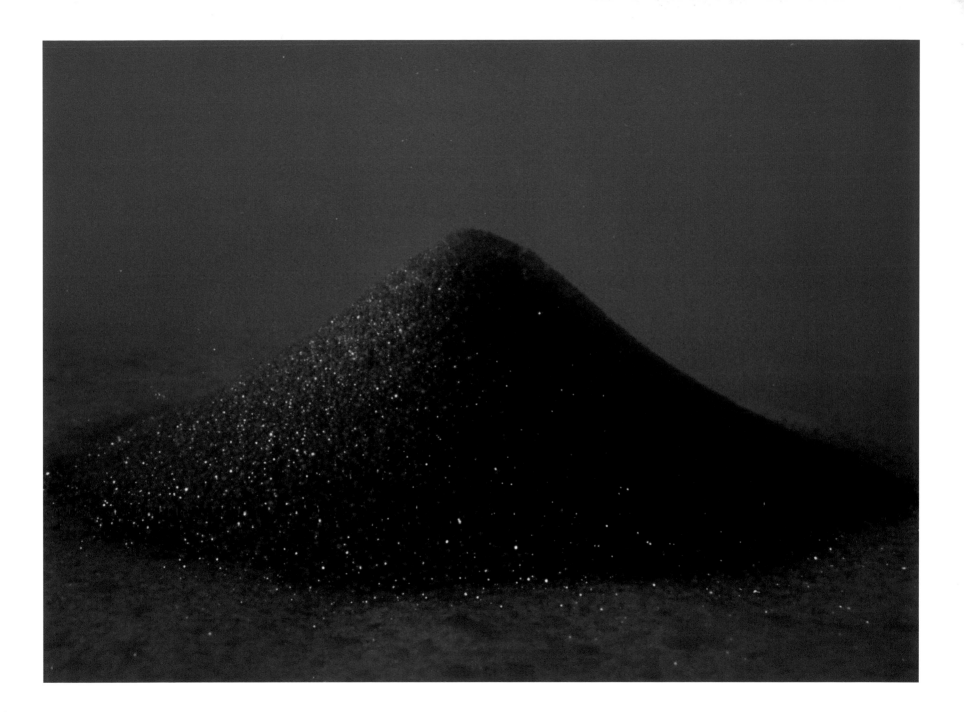

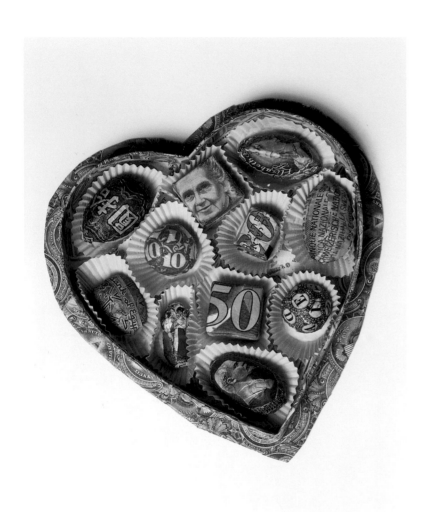 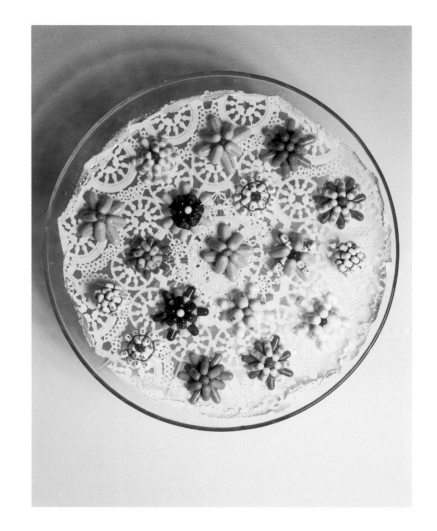

Barton Lidice Benes

Born 1942, Westwood, New Jersey

Sampler, 2002
Shredded money
11 × 13½ × 1½ inches
Loan courtesy Lennon, Weinberg, Inc.,
New York, NY

Petits Fours, 2001
AIDS pills, paper, and glass; lid: 12 inches
diameter; stand and lid: 12 inches height
Loan courtesy Lennon, Weinberg, Inc.,
New York, NY

Barton Lidice Benes comments on the fleeting nature of health, fame, and wealth with a ready wit and sly humor. A master recycler and compulsive collector, he fashions secular temples from discards and other everyday items, with each reconstituted object rescuing a particular moment in time. Grouped according to such themes as food, death, and hair, they form curiosity cabinets that both celebrate and critique the hopes and horrors of our celebrity-driven culture.

Drawn to unorthodox materials, Benes has used money as a medium since the early eighties. Early works involved fetishistic dolls, a crown of thorns, and pacifiers made of torn money. *Sampler*, a heart-shaped candy box covered with dollar bills, contains an assortment of bonbons masked with fragments of paper currency from around the world, bearing the face of Queen Elizabeth and bits of Arabic script. With a nod to Duchamp and Warhol, Benes adds new meaning to the term "sweet deal" while memorializing some of the currencies recently lost to the euro. The work, of course, has nothing sweet about it: The candy cannot be eaten, and the viewer is left to ponder tiny mummylike mysteries. His works with HIV-infected blood and *Petits Fours*, featuring clusters of brightly colored AIDS pills, are just as bittersweet. The latter is presented on a clear glass cake stand, which only deepens the installation's irony; together these works raise troubling questions about funding research for a cure for the disease.

By contrast, Benes's ongoing *Reliquaries* series wreaks havoc with the notion of authenticity and hierarchy. *Celebrity*, for example, includes Nancy Reagan's chocolate-smeared napkin and Kato Kaelin's lip balm, while *Disasters* features oil from the *Exxon Valdez* and a mosaic tile from Pompeii. The accompanying labels specify the objects' provenance and toy with the viewer's credulousness. Outrageous yet profound, Benes counterpoints absence and presence as he mines the darker side of our ideals and fantasies.

Rebeca Bollinger

Born 1960, Los Angeles, California

Faces of babies or children, disembodied and anonymous, peer out at us from their cookie bodies. Who are they and where do they come from? Rebeca Bollinger eschews curio shops and family attics, opting instead to surf the Web for her source material—home pages where strangers post private images of themselves and their families for all to see. Her works have the added irony of referencing the term "cookie." Cookies track browser preferences, and like the artist's cookies, blur the boundary between voyeur and visitor.

To make her cookie-cutter confections, Bollinger uses a so-called Sweet Art machine, a quirky, quasi-alchemical device she discovered in a computer magazine. Similar to an ink-jet printer, it transfers faces onto commercial cookies, or her own homemade variety, using ink or food dyes. The resulting ephemeral images conjure the missing children on milk cartons and parallel the temporal nature of food itself. Whether they boast large individual silhouettes or groupings of the same tiny face, these gripping portraits address the fragile construct of identity in a Web-based world. The antithesis of "sweet" or "precious," they also suggest something sinister, with decidedly cannibalistic overtones were they actually to be eaten. Bollinger adds another level of remove to these creations by encasing them in prophylactic plastic bags.

The cookie project is part of the artist's ongoing interest in creating a repository of images in response to the fragmentary and transparent nature of our computer reality. In recent videos, including *Fields* and *The Collection,* she catalogues and reforms aspects of the landscape or a museum's decorative arts holdings in a curious line-by-line method similar to that of the Sweet Art machine. For Bollinger, the various materials and subjects she treats—be they portraiture, landscape, or still life—all carry the same weight. The resulting works appear to emerge from nothingness and transport us to the edge of a familiar, yet uncharted, virtual frontier.

untitled (baby), 1997
Cookies, shrink wrap, cardboard
13 × 10 × ¾ inches
Loan courtesy Rena Bransten Gallery,
San Francisco, CA

untitled (nillas), 1997
Cookies, shrink wrap, cardboard
9 × 15 × 1 inches
Loan courtesy Rena Bransten Gallery,
San Francisco, CA

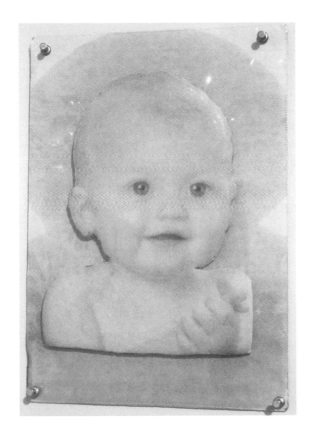

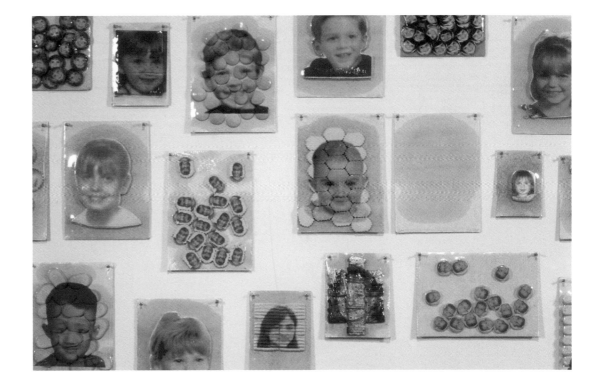

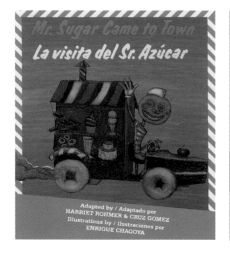

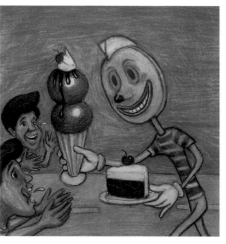

Enrique Chagoya

Born 1953, Mexico City, Mexico

Ever curious, Enrique Chagoya excavates past cultures and devours the artifacts, writings, and iconography of the world around him to create a cosmology all his own. A self-described "utopian cannibalist" engaged in "reverse anthropology," he upends the timeworn pattern of dominant cultures raiding their conquests by tampering with the original meanings and contexts of appropriated objects.

His boisterous pictures become a temporal no man's land where diverse and eclectic symbols enact a battle between barbarism and civilization. *Hidden Memories*, for example, juxtaposes a section from Monet's cherished *Water Lilies* with a fragment from an unidentified Aztec codex, possibly of the artist's invention. A barge becomes the stage for Manet's famous painting of Emperor Maximilian's execution, while the superimposed head of cartoon hero Tintin, known for his colonialist, racist views, floats alongside the Virgin Mary, nearly painted over in white.

The son of a noted painter, Chagoya was deeply affected by political unrest in Mexico in the late sixties. He moved to the United States and took up the cause of migrant workers. *Mr. Sugar Comes to Town* is his first collaboration with Children's Book Press. Adapted from an educational puppet show, the bilingual work tells the story of the duplicitous Mr. Sugar, who tricks children into becoming sweet-food junkies until a wise grandmother exposes him. Taking inspiration from a key figure in the popular Mexican graphic tradition, the lithographer and illustrator Jose Guadalupe Posado, who was noted for his biting commentary and his depictions of skeletons, Chagoya conjures a twisted version of the Good Humor truck with striking images in colored pencil and pastel.

Chagoya's fertile imagination transforms personal meditations into a new communal history, blending fact and fiction in an unsettling construct marked by a biting wit and sharp intellect. Always in flux, his global perspective bears the marks of the past even as it anticipates future culture wars, challenging audiences to reconsider the limitations of their own worldviews.

Mr. Sugar Comes to Town, 1989
Graphite and colored pencils
10 × 9½ inches
Cover, pages 11, 19, 29
Published by Children's Book Press,
San Francisco, CA

Mildred Howard

Born 1945, San Francisco, California

The dark impassive face of slain rapper Tupac Shakur looms up from the red silk lid of Mildred Howard's heart-shaped bonbon box. For stricken rapper Big E. Small, she created a dark brown, oblong container bearing an inscription that begins, "black and ugly. . . ." Like the sarcophagi of ancient Egypt, these boxes transcend time and place to become emblems of ephemeral celebrity. With deep psychological resonance, they redeem the horror and futility of loss with the grace and power of endurance—as their titles obliquely attest. Inside *Post-Traumatic Slave Syndrome: Don't Get it Twisted, This is Not My Real Life* nestle silk chocolate bonbons bearing photo-screened details of Shakur's face and bullets. In *Post-Traumatic Slave Syndrome: To the Bone*, bones and teeth wrapped in cellophane bundles are piled on top of American flags, which line the bottom of the box and remind us of our shared though troubled allegiances.

Howard first mined the metaphoric potential of the bonbon box with her *Some mo of Dem chocolate Heart* series in the late seventies, which enlisted one of the many strategies she has used to explore memory and address issues of race and identity. The stark, cast sculpture *Don't Slap the Hand*, for example, portrays a white hand grasping a dark glass replica of the famous Aunt Jemima statuette. *Black as What* cleverly upends a Marcel Duchamp readymade art object by substituting a black iron skillet for a bicycle wheel mounted on a stool. With immediate references to African American history, the back of the pan also has a decidedly surreal flavor. A gilt-framed mirror peers out like an eye, and evokes the glass found in some Kongo *minkisi*, magical figurines used to effect change. As viewers see themselves reflected, their curiosity turns into responsibility. By recontextualizing familiar and often familial objects, Howard exposes how attitudes are formed, handed down, and how they may be potentially transformed.

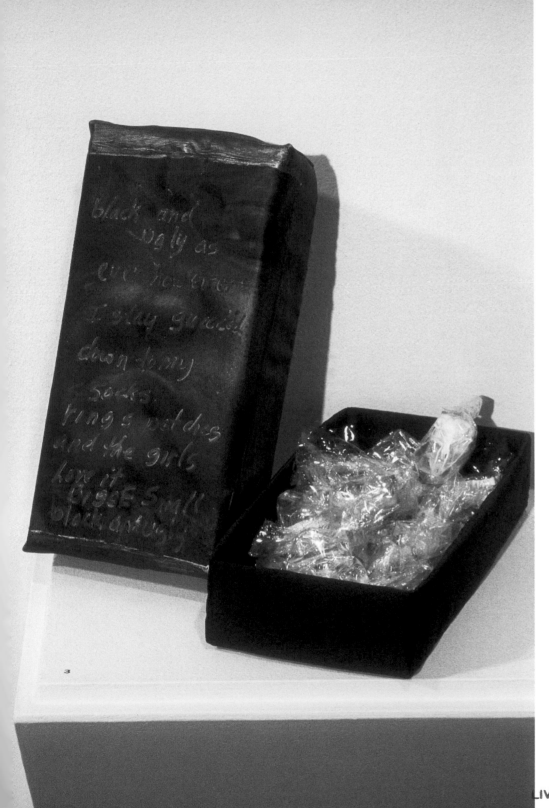

3

Post-Traumatic Slave Syndrome: To the Bone,
2001
Resin, bones, teeth, cellophane wrappers
in handmade silk box
10 × 5 × 2 inches
Loan courtesy Gallery Paule Anglim,
San Francisco, CA and the artist

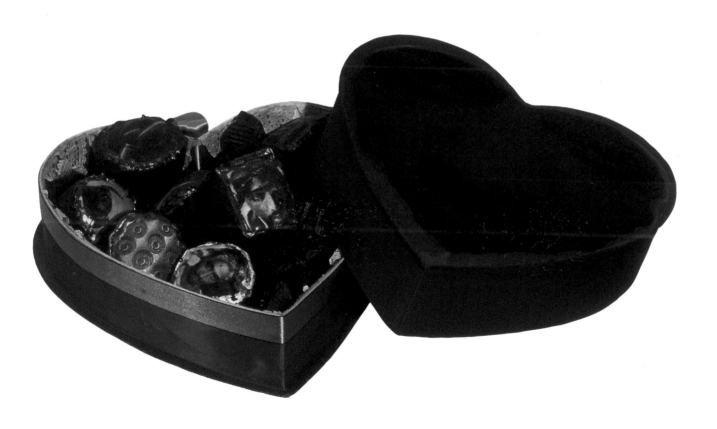

Post-Traumatic Slave Syndrome: Don't Get it Twisted, This is Not My Real Life, 2001
Hand-sewn silk with photo transfers in handmade box
8 × 9 × 2 inches
Loan courtesy Tupac Amaru Shakur Foundation

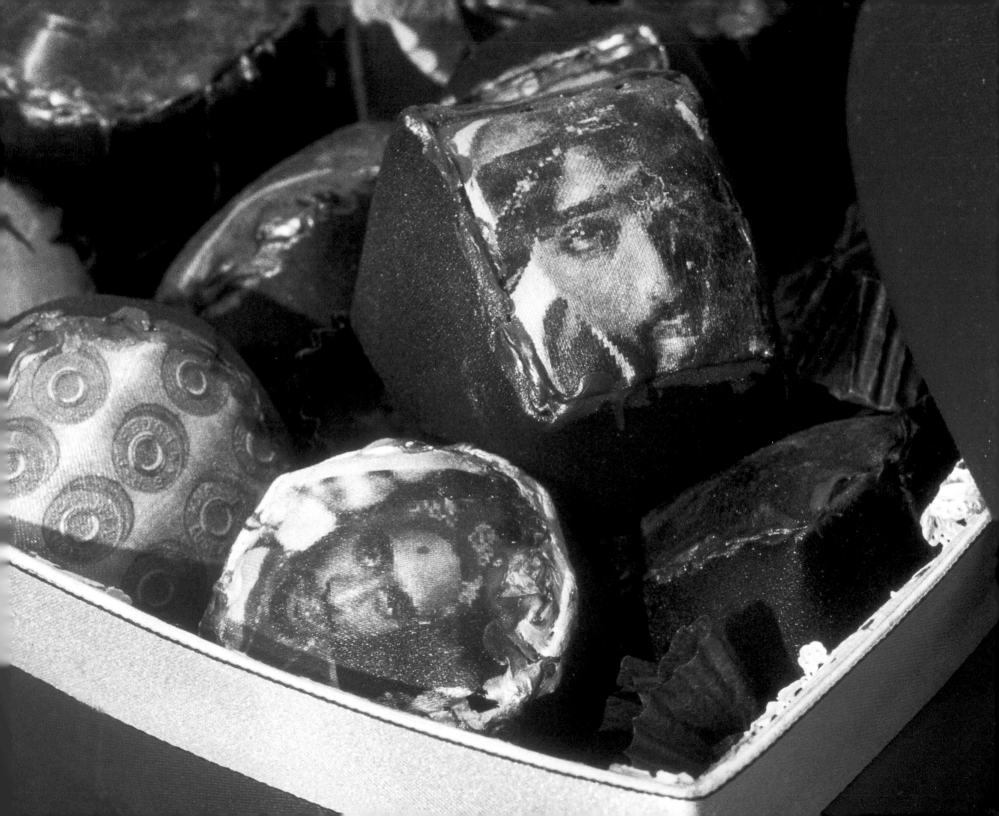

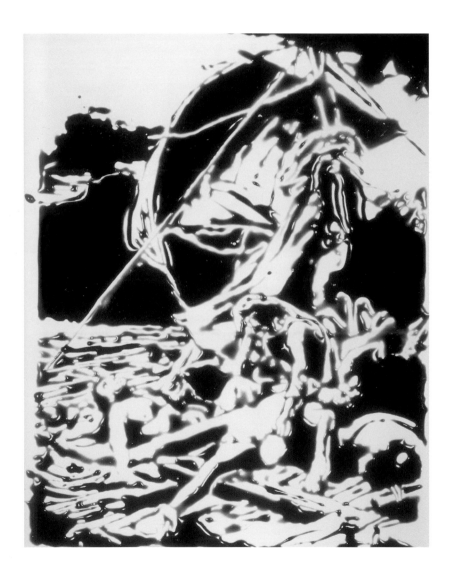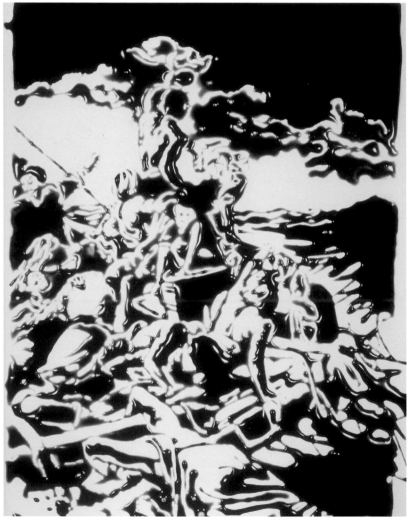

Vik Muniz

Born 1961, São Paulo, Brazil

Raft of the Medusa, 1999
Silver dye bleach print (Ilfochrome)
Two parts: 90 × 120 inches
Loan courtesy Ronald W. Garrity

Chocolate—the stuff of dreams? In Vik Muniz's *Pictures of Chocolate* series, the sticky, aromatic material titillates the senses while magically re-creating images from history and art history. A self-described "low-tech illusionist," Muniz creates new avenues of communication and arouses viewers' curiosity with unexpected materials.

Since the late eighties, Muniz has salvaged and recontextualized the likes of dirt, ketchup, sewing thread, garbage, dust, sugar, and chocolate. Each experiment reinvents a source image, often a well-known painting, photograph, or drawing. He has interpreted an Alfred Stieglitz cloud study with cotton balls, for example, and a Claude Lorrain landscape using 1,750 yards of thread. In his *Aftermath* series, debris such as cigarettes, confetti, and bottle caps left behind by Carnival revelers morph into haunting portraits of children.

With *Pictures of Chocolate,* Muniz has increased scale and switched to color photography for the first time (chocolate in black and white reads too much like blood), achieving wondrous faux finishes and webs that call to mind Jackson Pollock's drip paintings. In *Raft of the Medusa,* the conundrum between what is real and what is illusion reaches new heights as he maximizes the chocolate's metaphoric and associative potential. The work is based on Théodore Gericault's 1819 painting of a shipwreck (an incident that was a political scandal at the time). Muniz translated the horrific tragedy of sick and dying sailors by applying Bosco syrup with a needle onto a sheet of white plastic, which he then photographed. The finished print emulates the monumental size of Gericault's work, poignantly juxtaposing a sense of abundance and chocolate's luscious appeal against a writhing image of starvation.

In our virtual image-driven world, Muniz reminds us of the power of the hand. By playing with our expected ideas of materiality and appearance, he hones in on the photograph's ability to tell the truth, reminding us of the medium's ability to deceive, and questions its ability to capture a moment with the ephemeral nature of his materials. With these sleights of hand the artist removes the veil separating the living and the dead, asking us to regard the qualities of being and nonbeing in a new light.

Jana Sterbak

Born 1955, Prague, Czechoslovakia

For over twenty years Jana Sterbak has created exacting transfigurations using sculpture, installation, performance, video, and film. Through the passage of time or human intervention, simple objects become symbols of change or loss. In so doing they revolutionize not only our understanding of physical, nonsentient matter but also our awareness of self.

Sterbak typically uses a personal experience or an insight gleaned from recent reading as a point of departure, and then seeks to express its appropriate plastic embodiment, guided by the intended transpersonal message and the exigencies of the exhibition space. The results, always startling and deeply poetic, fuse the internal logic of the piece with its timeless potential. *Vanitas: Flesh Dress for Albino Anorectic* was first worn by a woman and then left to rot on a mannequin. *Inside,* a mirrored coffin encased in multifaceted glass, bridges private and public domains as viewers contemplate the fractured reflections of themselves and each other. *Bread Bed,* an austere four-poster metal bed frame with a bread mattress, brings together two basic life-sustaining necessities—sleep and food. *Catacombs* transforms the idea of preserving human bones into a quintessential expression of "death by chocolate." The more recent *Dissolution* features a cluster of ten to sixteen ice chairs that are melting at different rates, causing the metal frames to crash to the floor and upset our expectations of support and sound.

Sterbak's extensive travel and exposure to foreign cultures have taught her the volatility of language as well as the importance of the physical object and its material properties. In her ongoing quest to orchestrate paradoxical situations, idea and object simultaneously convey conflicting needs and desires. Easily recognizable and intellectually challenging, her works resonate with art aficionados and the general public alike. Exploring what Sterbak calls "the interdependence of the sensible and the inert," they magically draw attention to the porous membrane that divides the living and the dead.

Caracombs, 1992
Chocolate
Dimensions variable
Loan courtesy Donald Young Gallery,
Chicago, IL

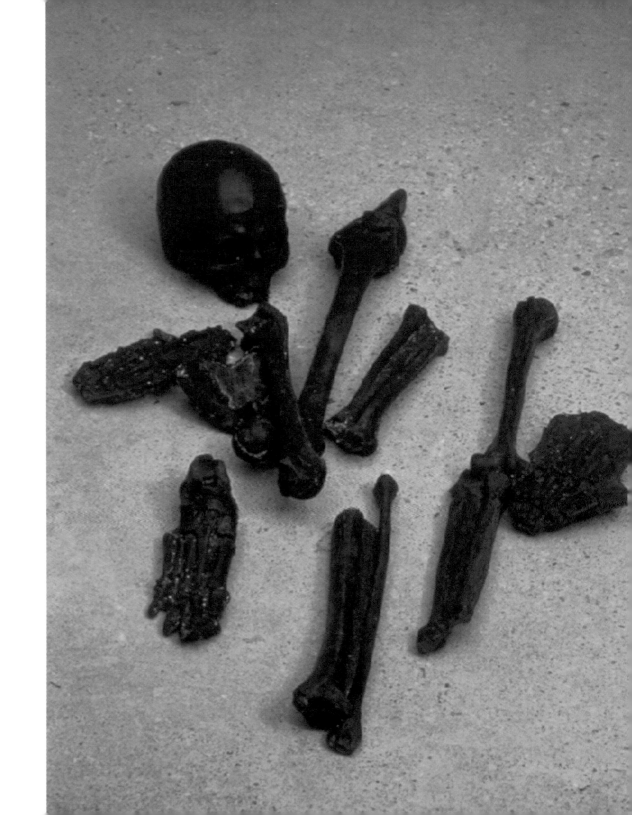

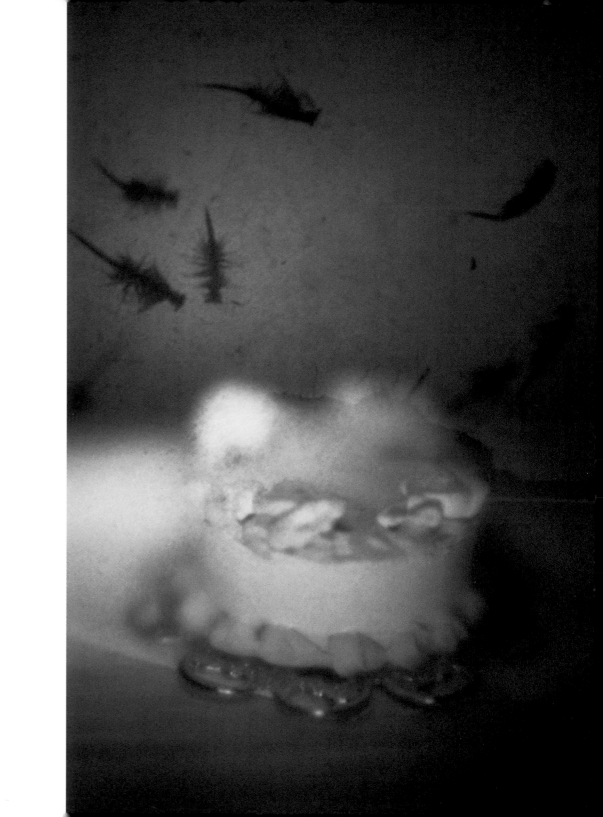

Let's Eat Inside, 2001
Projected installation with food and live
Sea-Monkeys
3 towers, each 8 × 20 × 20 inches

Ted Victoria

Born 1944, Riverhead, New York

A live still life and a real illusion may seem contradictory, but Ted Victoria's innovative and confounding updates of still life and landscape conventions tease the imagination and play with perception. Take *Let's Eat Inside*. In this dynamic tableau, a group of Sea-Monkeys, or brine shrimp, buzzes around a tiny cake and other edibles like a swarm of insects ruining a summer picnic. Viewers play the role of witnesses to this mise-en-scène, as well as that of the invisible party being forced to seek shelter inside a house.

Victoria has been experimenting with the creation, presentation, and poetics of the traditional still life for over thirty years. Improvising with a camera obscura and mirrors, he created elaborate projections based on stage sets and encloses them in shallow, wall-mounted light boxes or large, standing towers. Essentially low-tech, the artist's devices produce effects that are just as magical as those of the original sixteenth-century contraption, eschewing the purely invented possibilities of digital art. His compositions, often using architectural or landscape backgrounds, combine artificial and actual subjects such as a clock, telephone, pistol, furniture, floral bouquets, parts of a half-eaten crab, and Sea-Monkeys (ironically, these creatures are themselves fed to fish and are thus participants in the food chain).

In these mesmerizing, open-ended narratives, objects morphing slowly in real time rhythmically counterpoint static timeless items. An implied human presence triggers a range of emotional responses from humorous to ominous. Variations in the depth of field, focus, and light source produce a hallucinatory dematerialization that heightens the sense of dislocated time and place. Like a Joseph Cornell box brought to life, Victoria's hybrids take you on a journey of the imagination where something tantalizing can only be consumed by the mind.

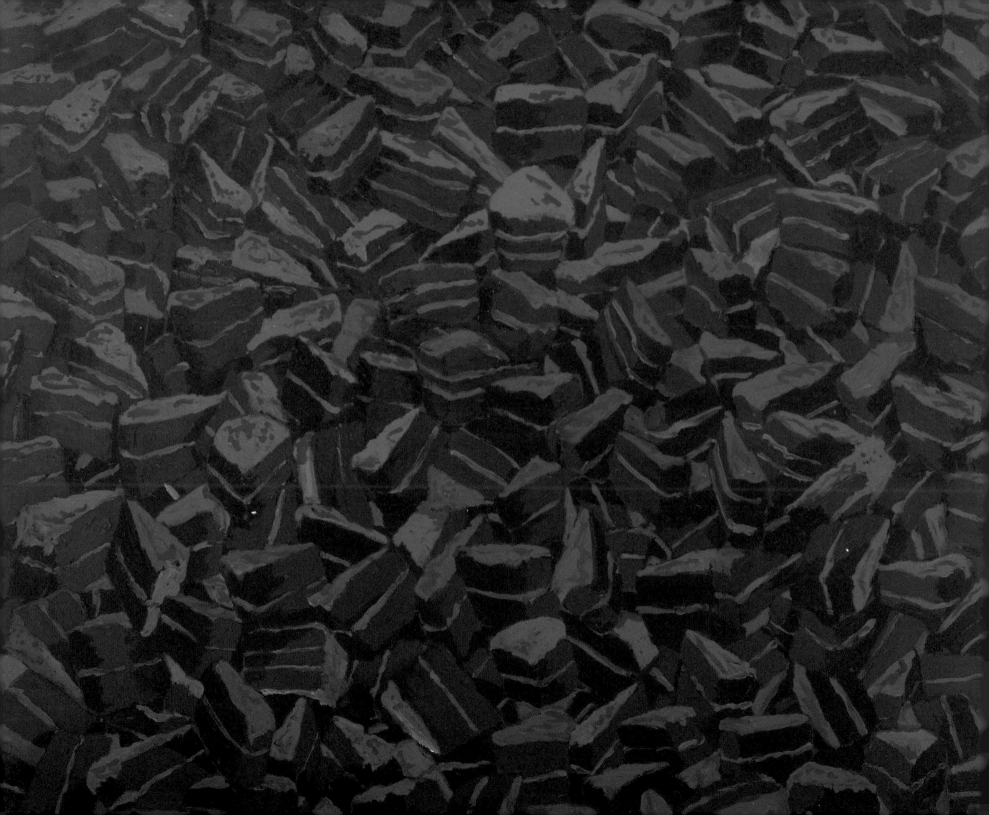

Socialized
Confections

In this chapter, the meaning of the still life is rooted in the social realm, and imagery provides clues to the artists and their cultures of origin. In traditional still life, standard trade items such as exotic fruit signaled the socioeconomic status of the patron. By extension, sweets can become human and cultural stand-ins, signifiers of values that are often contested or in flux. In our image-saturated contemporary society, some artists focus on the packaging and marketing of consumer goods. Drained of their commercial function, the reinvented staples become quasi-fetishes and, like boomerangs, point out human foibles. Desire, however, remains the primary motivator, even when the emblem seems to have replaced the original.

Andy Warhol and Robert Arneson, both trained commercial artists, deal opposing death blows to the glass tower of high art. Warhol exploited the depersonalized and democratic qualities of mass consumer products, manipulating the repetitive nature and Day-Glo palette of their advertised images. In the end he elevated his own taste to art, turning inanimate objects as well as people, including himself, into deadpan commodities. By contrast, Arneson emphasized the personal and the emotional, endowing his works with a boisterous humor,

59

autobiographic narrative, and socially conscious message. He raised the medium of ceramics to the pantheon of high art while recalling early examples of still life realized in clay. Part storyteller and part trickster, Robert Colescott points out racial messages underlying kitsch items and art history; in the painting *Le Cubisme: Chocolate Cake*, the artist wreaks havoc on what is deemed good taste and what—to him—tastes good.

Claes Oldenburg, who once challenged the art market by using a section of his studio as a store, also mines consumer culture for source material. His iconic Popsicles and baked goods, initially props for the "Happenings" of the sixties, play with our conventional sense of scale and texture. Similarly, Paul Kittelson's oversize replicas in painted hydrocal, a form of plaster, explore how all-American junk food takes advantage of our emotions and cravings by providing only "empty calories." Charlotte Kruk constructs sexy outfits for men and women from candy wrappers and boxes. Like Warhol, she explores the appeal of commercial branding and plays with its linguistic possibilities. Yet she also addresses socioeconomic status and cultural assumptions, as a comparison of her Godiva- and Hershey's-based clothing reveals.

Other artists use sweets as a starting point to focus on notions of beauty, desire, and the perception of women in contemporary culture. Recalling the visual dislocations of Surrealism, they often experiment with the concept of surrogacy and the use of juxtaposition. Laurie Simmons's photographs of dolls and confection hybrids probe repressed memories and dramatize in miniature the roles of housewife and sex object. In a photograph such as *The Wedding*, Sandy Skoglund constructs a life-size environment with strawberry jam and orange marmalade to explore ideas of ritual, excess, and vacillations between attraction and repulsion. Barbara Curtis Ratcliff explores the implications of the cake as a gift bearing socially conditioned and mixed meanings, and as a staging area for human drama. Angela Lim's soft fabric re-creations with embroidered text turn vulnerability and dissatisfaction into weapons, while Julia Jacquette subverts the nostalgic and romanticized appeal of magazine ads and cookbooks in glossy enamel paintings whose confessional labeling expresses longing and imperfection.

Blueberry Pie N°9, 1971
Earthenware
9 × 19½ × 5½ inches
Loan courtesy Norma Schlesinger

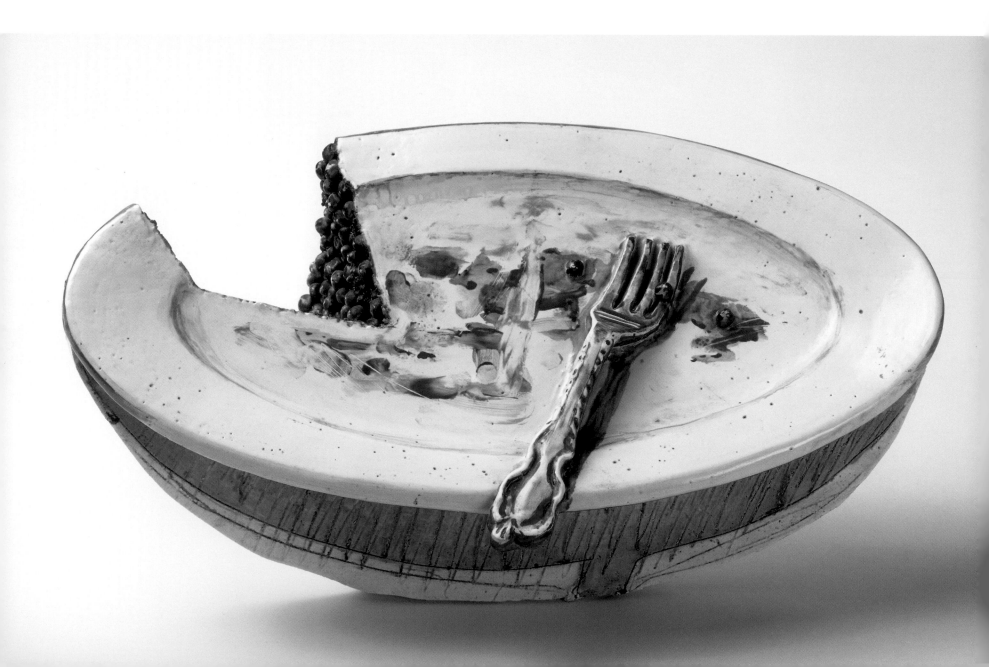

Robert Arneson

Born 1930, Benicia, California
Died 1992, Benicia, California

Up to his final battle with cancer, Robert Arneson, who was a rascal with a social conscience, composed work that engages our senses, morals, and minds. His interest in art began in high school, when he contributed cartoons to his hometown newspaper. By the end of his life, he had mastered graphics, painting, bronze, and especially ceramics, winning acceptance of the medium by the art world. In the early sixties he eschewed the pioneering work of Peter Voulkos and the then prevailing aesthetic of Abstract Expressionism. Instead he made humorous works such as *Typewriter* and *Call Girl,* which riffed on Duchamp's readymades and Surrealism's hybrids. Marked by a personalized, mock-heroic approach to content and material, the emerging Funk Art movement served as a dynamic West Coast counterpoint to Pop Art's deadpan detachment on the East Coast.

One of Arneson's many innovations was applying paint to white clay as though it were canvas. After Alice, his beloved house in Davis, California, was damaged by fire in 1969, he returned to his nearby hometown of Benicia. Inspired by his family dinner plates and the banal rituals of eating, he created his *Dirty Dishes* series, which shows meals in various stages of consumption. In *Blueberry Pie N°9,* he distorts conventional perspective by tilting the plate enticingly toward the viewer, emphasizing motion through gestural sweeps and the inclusion of a fork, which cantilevers perilously over the rim of the plate. Enlarging the scale, the pie becomes a self-referential object, a stand-in for the artist, and a metaphor for home. Concurrently he worked on *Smorgi-Bob, The Chef,* his first large-scale tableau with his portrait at the apex.

In addition to household items, Arneson undertook several major themes in his career, turning clay bricks and self-portraits into vehicles for exploring civilization and identity. Rich in verbal and visual puns, his brutally honest work continues to inspire psychological insight and profound humanism, while the legacy of his generous teaching lives on in countless generations of students.

Julia Jacquette

Born 1964, New York, New York

What could be more tempting than a row of alluring desserts painted on a bright aqua background? Just as you draw near and start salivating, the text gives you pause: *Andrew, Michael....* The list of classic male names continues until you reach the title, *Six Men*, which says it all.

Julia Jacquette culls fifties and sixties magazines and cookbooks for her subjects and also draws upon childhood memories. The food in her paintings, as delectable as it appears, is always shown uneaten, communicating desire, anticipation, or disappointment. It cuts right to the libido, where logic is dismissed and pleasing the flesh commingles with consuming food. Early on, Jacquette conceived the pictogram format to present generic images of food, hands, and flowers—images that, when combined with text in exaggerated curvilinear script, become the quintessential means to critique ideals of feminine beauty, elegance, and perfection. Jacquette is inspired by René Magritte for his ambivalent juxtaposition of image and text, Andy Warhol for his fascination with commodity and fetish, and Ed Ruscha for his sheer joy of experimenting with texture and material.

Some paintings explore gender politics with meat and savories as surrogates for men, and eggs or sweets for women. Others concentrate strictly on socially conditioned attitudes toward women. *If Only You Thought I Was as Beautiful as My Paintings* cleverly addresses the role of the artist and the longing—at times obsessive—to be accepted. Jacquette is currently focusing on weddings as a kind of parody and homage to Robert Ryman's white paintings, with close-ups of brides, cakes, and bouquets treated in her hyper-decorative manner and arranged in a grid format.

Using enamel, a glossy material conceptually attuned to her work, Jacquette orchestrates equivocal scenarios colored with humorous bravado and aching nostalgia. Hard, impenetrable surfaces set off their soft, vulnerable subjects and interact with the curious, intrigued viewer.

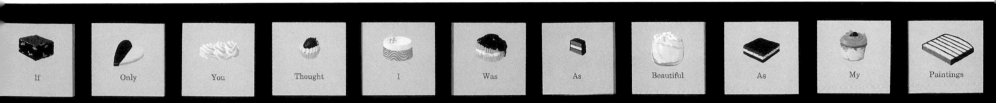

If Only You Thought I Was As Beautiful As My Paintings

If Only You Thought, 1994
Enamel on wood
11 panels, each 8 × 8 inches
Loan courtesy Jean Yves Noblet

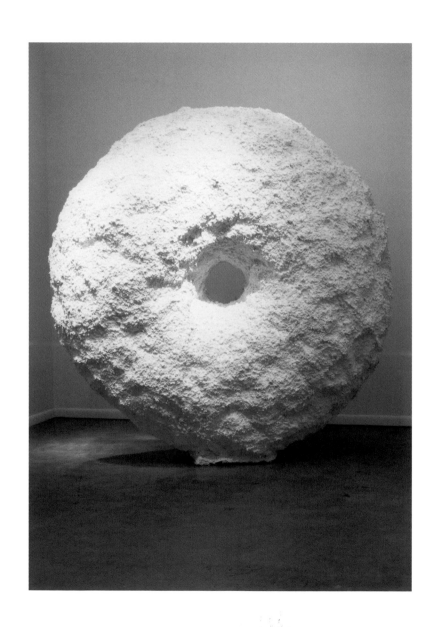

Paul Kittelson

Born 1959, Wheaton, Minnesota

Powder, 1998–2002
Hydrocal, wire, and Styrofoam
92 × 90 × 36 inches

A curtain of marshmallows, a dangling string of rippled potato chips, a row of bright molded Jell-O, and other equally tempting oversize replicas of all-American junk food—Paul Kittelson plays not only with our sense of taste but also, with delightful doses of humor and wit, our sense of disbelief. The sculptor has mastered the art of hydrocal, a hard form of plaster often molded over a wire armature. When concrete pigments are added, the material allows for magical sleights of hand.

Following the line of exploration initiated by Claes Oldenburg several decades ago, Kittelson takes familiar bits of our everyday existence and transforms them into whimsical critiques by altering their scale. Food, in particular, couples his interest in tactility with an uncanny ability to stimulate our deepest sensual appetites. The self-described Minimalist's sculptures may also be appreciated for their variations in shape, color, line, and surface as well as for their references to art history. A powdered doughnut with an eighty-four-inch diameter, simply titled *Powder*, is a classic reductive composition of a negative hole within a positive circle. By contrast, *Rejection* features a pile of oversize broken valentine candies in predictable insipid pastels. It pulls on our sentimental strings while exploiting hydrocal's ability to contrast soft surfaces and jagged contours. The more sexually charged *Gummy Bear with Cherry* has a maraschino cherry balancing on the back of a chocolate gummy bear on all fours.

A key player in the Houston art scene, Kittelson is well known for his collaborations and public works. Over the years he has been involved with the Art Car Parade, created a dinosaur bone park for a local elementary school, and participated in the Project Row Houses After School Programs. Rich in associations, his fanciful sculpture is marked with a sense of immediacy and a fingertip reality.

Her, She Says Kisses, 1996
Hershey's candy bar and Kisses
wrappers

*"She Said, 'These are Good, But You've
Had Plenty,'"* 1996
Recycled Good & Plenty boxes, size 8

Charlotte Kruk

Born 1971, Campbell, CA

Too good to eat, perhaps, but definitely good enough to wear! Eye candy takes on an entirely new meaning with Charlotte Kruk's sculptural candy-wrapper clothing. A Good & Plenty dress, a Bit-O-Honey bikini, a Godiva cape—these are just a few of the artist's creations.

An interest in metalworking and a lifelong passion for sweets came together for Kruk in the early nineties, when she started making cabochons featuring marketing slogans from brand-name candy. Junior Mints inspired a "creamy" pin that, when worn, puts a subversive spin on the relationship between women and sweets. Kruk soon realized that making dresses was a more practical way to go. She took sewing lessons from her mother and began stitching together the packaging from candies she had purchased and eaten. Incorporating both found and improvised patterns, her sexy outfits for men and women are not only funky fashion statements but also, ironically, as suggestive and delectable as their original packaging is intended to be. The clear plastic sheathing of the "fabric" even renders the garments strangely prophylactic.

A recycler of sorts, Kruk is fascinated by a society that creates a branding mystique intended to drive us to devour sweets, only to throw the precious packaging away. Also fueling the artist's creations is her play with language, as in such works as *"She Said, 'These are Good, But You've Had Plenty,'"* made from Good & Plenty cartons; *Feel It, Taste It, Wear The Sensation,* composed of York Peppermint Patty wrappers; and the more recent *Betty's Moistest Ever!,* constructed from recycled boxes of Betty Crocker cake mix. In this way she links herself to Andy Warhol's over-the-top statements on mass-produced items and commercial advertising and Claes Oldenburg's soft and plaster sculptures of consumable goods. Kruk's works assume a personal presence, as they are taken specifically from her life. Equally distinguishing ideas are an underlying feminist critique and a class-based commentary, as revealed by her regal, full-length Godiva chocolates cape. Yet, in the end, it is the transformation of such mundane castaways into clothing that makes Kruk's sculptures stir the imagination in such an enticing way.

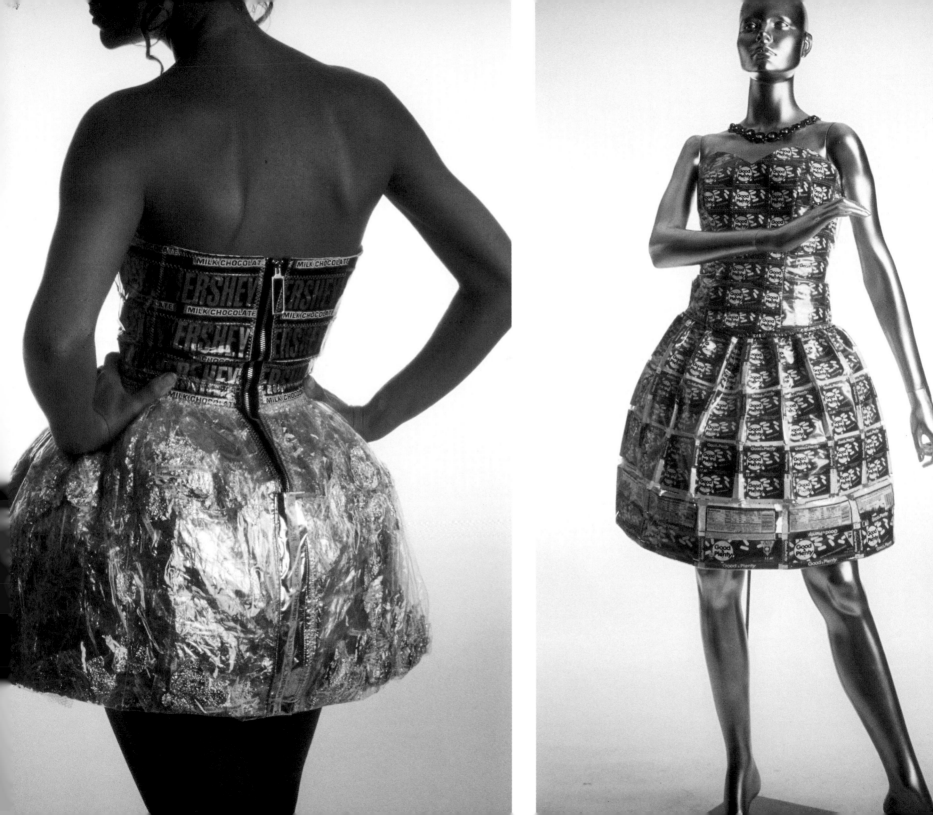

Angela Lim

Born 1965, Hong Kong

Intimate, inviting, precious, and delicate, Angela Lim's hand-stitched sculptures of beds, aprons, and vessels may look homey and sweet on the outside, but on the inside they pulse with bitterness and grief.

For the last several years Lim has concerned herself with the tug of war between desire and duty, and the role of women in society. The lasting impact of her Chinese heritage can be seen in the values of familial duty—bordering on bondage—and sewing, both signaling a proper upbringing and observance of tradition. Her early training in the craft of sewing finds full expression in her labor-intensive, even obsessive, output, which complements the brooding passion of its content. Equally as important to the overall meaning of the pieces, her embroidered verse often narrates tales of inner turmoil or forms the basis of titles. This play with words is rendered especially effective by contrasting a reproachful work like *Pose,* which features an ironing board and asserts, "Don't you ever ask me if I am experienced/As if you care . . ." with *Cockaigne,* a rose-bordered sampler that concludes, "In the throes of the pose/the mode and/the metamorphosed/Amend."

Sweet Domain engages in a pointed exploration of the adage "Home Sweet Home" and the woman's position as head of household affairs. The installation features a lineup of cloth pastries on commercial paper doilies; their ivory color is left intact, emphasizing the concepts of purity and perfection. As they reveal various aspects traditionally identified as feminine, Lim's works draw an uneasy parallel between sweets and women who are coveted, consumed, and forgotten. One of her sculptures, *Perfect Role, Profiteroles,* replaces the pastry's spun sugar with fake doll hair for the arabesque drizzle of the central tower. Surrounding it, a smaller tower and cream puffs are adorned with objects that suggest expected roles. Nipple-like snaps allude to the duties of sewing and the status quo. Pale pink fake nails and black artificial eyelashes explore ideas of beauty, and a flourish of faux pearls in a state of unraveling becomes an ominous reality check. As do Lim's other works, *Sweet Domain* poignantly juxtaposes household chores with the price of beauty and the strain of labor.

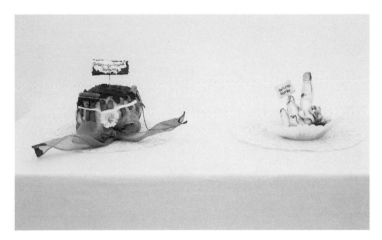 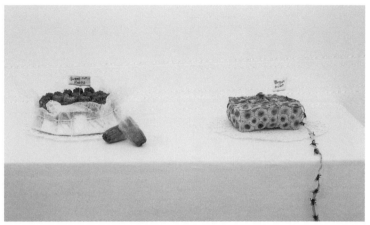

Left, *Sweet Domain: Dreary-go-round Ganache,* 1996, mixed media with hand embroidery, 3½ × 4 inches diameter; right, *Sweet Domain: Bananas Flambe,* 1996, mixed media with hand embroidery, 4 × 2½ inches diameter. Loan courtesy Catharine Clark Gallery, San Francisco, CA

Left, *Sweet Domain: Sweet Rum Rockets,* 1996, mixed media with hand embroidery, 2 × 5½ inches diameter; right, *Sweet Domain: Blossom Brûlée,* 1996, mixed media with hand embroidery, 1¾ × 5 × 3½ inches. Loan courtesy Catharine Clark Gallery, San Francisco, CA

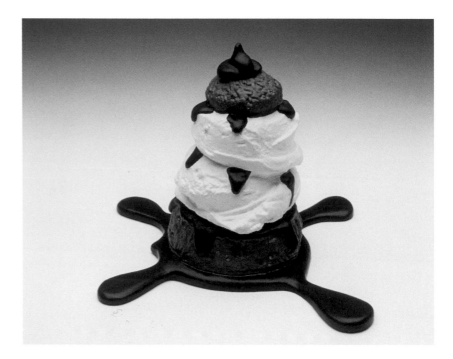

Profiterole, 1990
Lithograph
31¼ × 41 inches
Loan courtesy Gemini G.E.L., Los Angeles, CA

Profiterole, 1989
Cast aluminum, latex paint, and brass
6 × 6½ × 8¾ inches
Loan courtesy Claes Oldenburg and Gemini
G.E.L., Los Angeles, CA

Claes Oldenburg

Born 1929, Stockholm, Sweden

A high priest of contemporary art, Claes Oldenburg mixes humor, wit, and a keen sense of the theater in works that continue to delight broad audiences and inspire generations of artists. The son of a diplomat, he grew up in Chicago, becoming an American citizen in 1953. After working at a newspaper, he moved to New York in 1956, where he and Coosje van Bruggen, his wife and frequent collaborator, presently live.

An initial interest in drawing and painting led to an involvement in Happenings and environmental artworks in the late fifties and early sixties. As he mined the gap between art and life, he began drawing store goods and incorporating discarded consumer products into his art. From 1961 to 1962, in a radical departure from art gallery practice, he sold his painted plaster food and clothing articles at the Store or the Ray Gun Mfg. Co., part of his own studio on 107 Last Second Street. A year later he created his first oversize soft sculptures of an ice cream cone and a wedge of chocolate cake, and in 1965 he initiated his series of *Proposed Colossal Monuments*, including *Fork Cutting Cake No. 1: Proposed Colossal Monument for Picadilly Circus, London*. Since then, he has produced over thirty-five large-scale public sculptures, among them his beloved *Batcolumn* in Chicago.

In recent years Oldenburg has partnered on several occasions with Gemini G.E.L., an innovative workshop dedicated to the creation of prints and limited-edition sculpture. The cast sculpture and lithograph for *Profiterole*, realized in 1990, reflect the artist's ongoing exploration of libidinal desire and the mock-heroic, simultaneously capturing the sensual moment of a dessert melting. Today Oldenburg continues to find passion and beauty in the mundane, making everyday objects come alive through changes in material, texture, and scale. "I am for an art that is political-erotic-mystical," he has said, "an art that takes its form from the lines of life, that twists and extends impossibly and accumulates and spits and drips . . ."

Mary Curtis Ratcliff

Born 1942, Chicago, Illinois

In Mary Curtis Ratcliff's *Mixed Messages,* decorated cakes become stages where dramas unfold, oscillating between something sugary and inviting and actual meaning. As the artist explains, "The juxtaposition of the sweetness of the cakes, offered as gifts, and the often repressive messages inscribed on them evoke the duality of early conditioning: What we give with one hand we take away with the other." This idea can be seen as part of a larger social phenomenon in which gift giving places the receiver in the donor's debt, which may be an uncomfortable position.

Ratcliff began working on this series a few years ago when, after receiving a gift basket, she saw it transformed into a cake upon awakening from a dream. She incorporated the basket's cellophane wrapping and ribbon into her first confection, *Question Cake,* and placed it on a stand. Subsequent cakes play off common expressions. In *Baby Cakes,* for example, five small, pink-and-white cakes on a "found object" highchair condemn with the judgmental observation "She's cute but she's dumb," written in a frilly script. The inscription accompanying *Wedding Cake* laments "It seemed like a good idea at the time." Other projects honor famous people. In *Homage to Barbara Bush,* a slice of yellow cake adorned with Bush's signature fake pearls emerges from a splash of white fur, while in *Homage to Liberace,* a tiny candelabra perches on top of a two-tiered slice of cake frosted in black sequins and encased in a glass dome. Experimenting with some thirty pastry tips and traditional decorating patterns, Ratcliff models her surfaces with a special acrylic, Perma Ice, which approximates butter-cream frosting.

More recent works tend to be more abstract, either treating decorated segments as architectural panels or camouflaging cakes within larger, 1950s-style wallpaper patterns. As she continues to explore unconventional materials, Ratcliff remains interested in women's issues, themes of domesticity, and the interface between spiritual and cultural realms.

Homage to Barbara Bush, 1998
Steel, plaster, acrylic, and mixed media
50½ × 19 × 19 inches

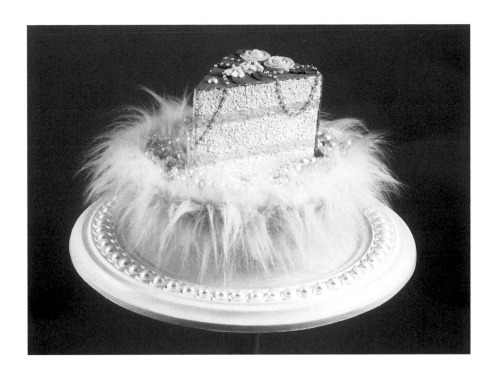

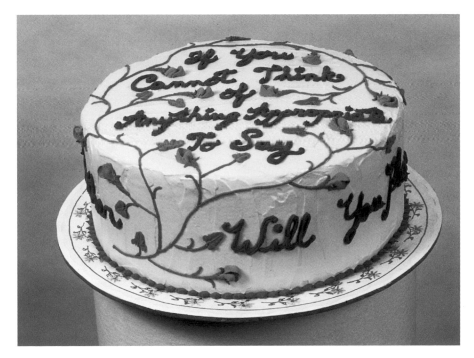

Jane Austen Cake ("If You Cannot Think of Anything Appropriate to Say"), 1996
Steel, plaster, and acrylic
5¼ × 14 × 14 inches

Laurie Simmons

Born 1949, Far Rockaway, New York

What could be more surreal than a giant, sickly sweet cake held up by tiny pink plastic girlie legs? Not only does this image question the relationship between woman and beauty, but the title, *Alles Liebe* (the literal translation "all love" implies "I wish all love"), also speaks ironically of longing and desire.

After finishing art school and living on a farm in upstate New York, Laurie Simmons moved to New York in 1973, a time when Conceptual and Process art were opening up worlds of possibilities. Feminism was also defining its own critical outlook, but it was incumbent on the artist to figure out what she was trying to say before determining how. For Simmons and her colleagues Cindy Sherman, Louise Lawler, Barbara Kruger, and Sherrie Levine, photography, removed from its fine arts tradition, offered the answer.

Irresistibly drawn to dollhouses, furniture, dolls, toys, and vintage wallpaper, Simmons started taking pictures of constructed miniature sets. Both personal and generalized, the images evoke memories of her archetypal fifties suburban childhood as portrayed in the idealized television and magazine ads of that period. Undidactic and unaggressive in their critique, they show the past as simultaneously beautiful and entrapping. Typically, a female doll stands alone in a bathroom or kitchen, engaged in a mundane housewifely chore. A profound sense of dislocation arises from the artist's play with perspective and scale, while the doll and the domestic interior challenge our perception of reality, artifice, and private and public space.

The brooding eeriness deepens in Simmons' *Ventriloquism* series, which endows male figures with personalities and the appearance of life, and in her *Walking and Lying* series, in which human beings and inanimate surrogates interact. Her work contains an element of sadness and suggests that animating inert objects is a kind of compensation for feelings of loneliness. As she continues to explore the depiction of women in mass media and their role in a male-dominated society, Simmons' photography operates as a platform for the projection of dreams and fantasies and a touchstone for probing often repressed memories.

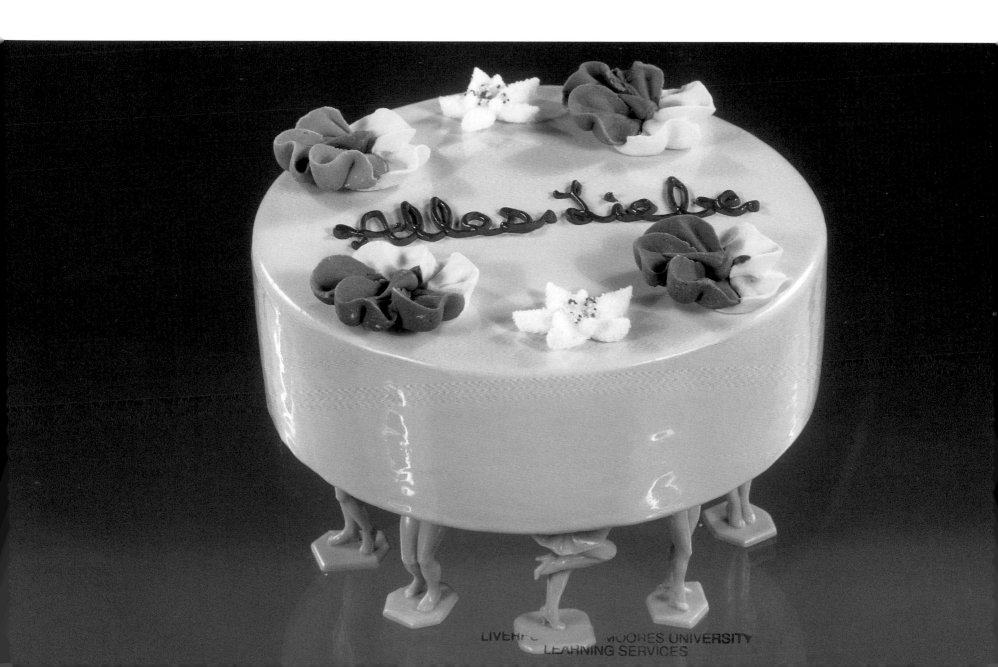

Alles Liebe (Vanilla), 1990
Cibachrome photograph
23 × 35 inches
Loan courtesy A.G. Rosen

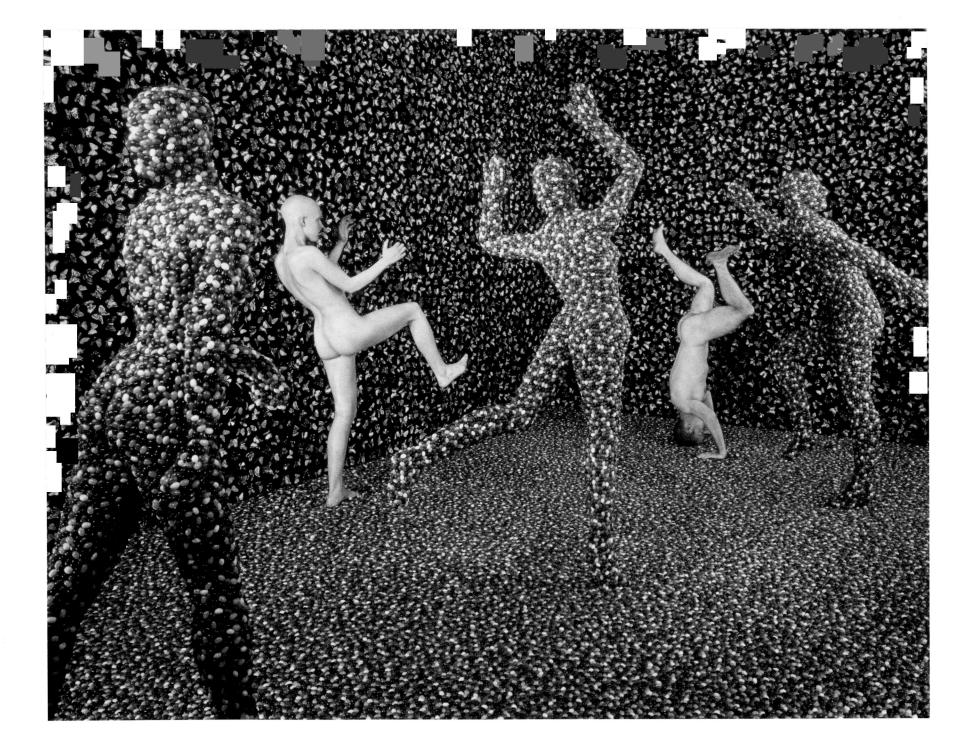

Sandy Skoglund

Born 1946, Quincy, Massachusetts

Shimmering Madness, 1998
Cibachrome photograph
36 × 46 inches
Loan courtesy The Collection of
Dale & Doug Anderson

Mannequins dotted with raisins, walls smeared with strawberry jam, a living room bristling with cheese puffs—these are some of the tasty treats from Sandy Skoglund's hallucinatory tableaux. Skoglund likens herself to a sociologist who probes her native culture from the outside; an interest in process and ritual is key to her idea-driven art.

Experimenting with nontraditional materials, she constructs elaborate environments that confound reality and fantasy in an unsettling yet often humorous manner. Brightly colored photographs of an installation complete her investigation of a theme, at once raising issues of mortality and preservation. In more recent works, the human figure lends scale and, in the artist's words, "functions as the psychological gateway."

Ideas of repetition and surplus reach new heights in *Shimmering Madness*. In this enigmatic pointillist environment, a dizzying mosaic of jellybeans—the artist specified that no two of the same color should touch each other—coat the floor and three mannequins. Their boundaries blur as they in turn counterpoint the walls, which are covered with fluttering butterflies, and contrast with two nude models cavorting on the floor. When does quantity compromise the quality of beauty? At what point do fragmentation and excess trigger sensory overload?

Skoglund grew up in the suburban consumer culture of the fifties, an experience that continues to influence her outlook and artistic output. She earned an M.A. in 1971 and an M.F.A. in 1972 from the University of Iowa in Iowa City. At the time the campus was a hotbed of cross-disciplinary thinking in religion, feminism, and politics. It was there that Skoglund began incorporating food in her imagery, such as peaches on the beach and sweet gherkins in a sunset. Upon graduation she moved to New York and set up her studio in Little Italy. Her early efforts involved xerography of found objects, and in 1974 she began working with photography.

Combining a Pop sensibility toward the everyday with Surrealism's love of the irrational, Skoglund creates lasting, idiosyncratic images that overturn expectations and encourage viewers to question the parameters of contemporary American life.

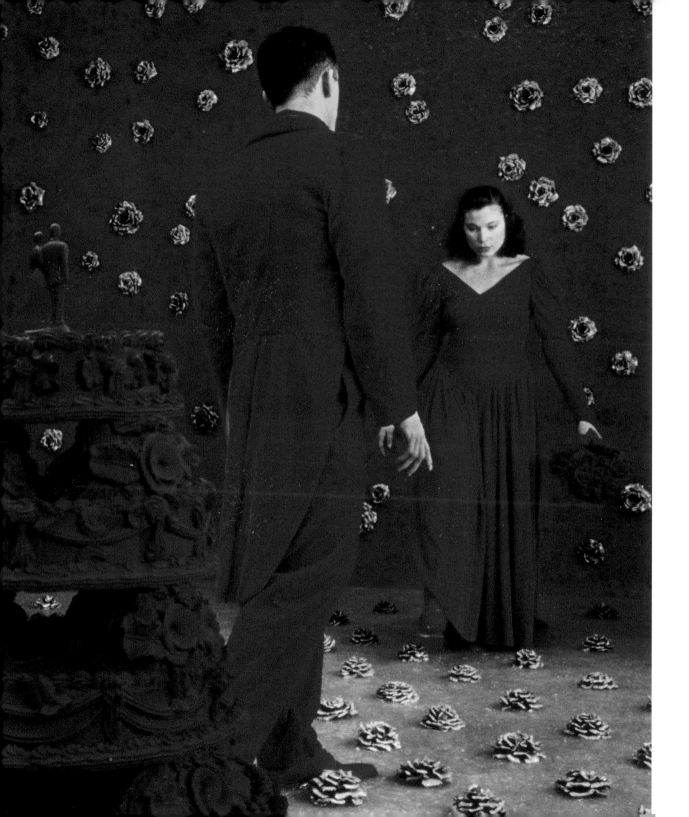

The Wedding, 1994
Cibachrome photograph
38½ × 48 inches
Loan courtesy Janet Borden Gallery,
New York, NY

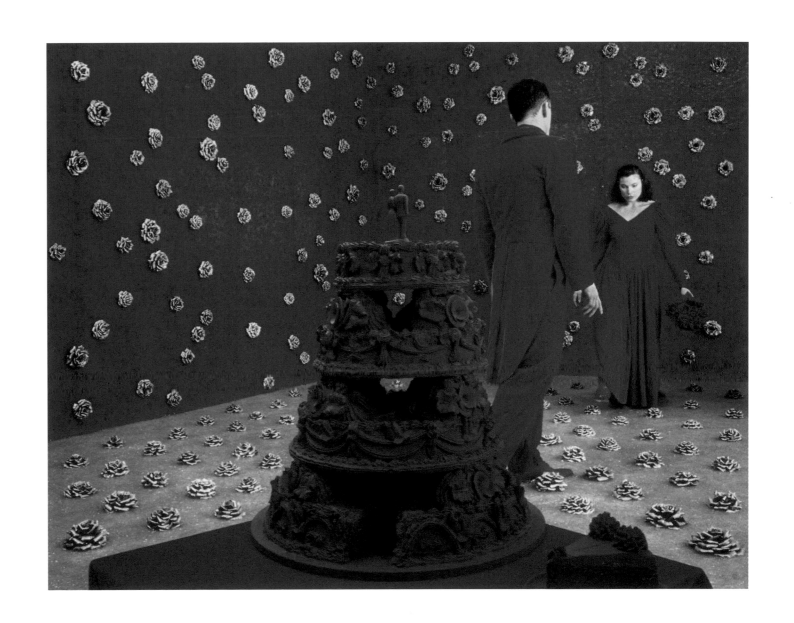

Andy Warhol

Born 1928, Pittsburgh, Pennsylvania
Died 1987, New York, New York

Throughout his prolific and protean career, Andy Warhol was fascinated by the vernacular and surface reality. A painter, photographer, sculptor, writer, filmmaker, performance artist, printmaker, and creator of the magazine *Interview*, he started as a commercial artist and ended up radically commingling the definitions of taste and art. As he explored surface, repetition, monotony, bright colors, and bold patterning, he exploited new methods of communication and advertising.

Often a contradictory message underlies the themes that have come to dominate Warhol's art—from his early paintings based on cartoon strips, to painted, sculpted and screenprinted consumer icons such as *Campbell's Soup Cans* and media-created celebrities, to his depictions of society's underbelly, including *Car Crash* and *Electric Chair,* and to his *Camouflage, Shadows,* and *Rorschach* works. Just as extreme was the Factory, the given name of his studio, which overturned the idea of the artist as a lone, heroic genius even as it promoted his own mystique. Ultimately, it was Warhol himself and his entourage that proved the most radical element of his art, becoming for some the recipient of their indifference when he too succumbed to media overload.

Life Savers, from Warhol's 1985 *Ads (ditto)* series, gently satirizes the role of commercials in shaping consumer culture. Appropriated from a found image, the work's depersonalized quality is emphasized through the screenprinting process, even as it plays to the viewer's emotions with its nostalgic claim of "still only 5¢." Equally ambivalent is the contrast between the Day-Glo palette, which points up the image's original function of encouraging desire and sales, and the polite request not to lick the page.

Warhol's art relied heavily on dissonance—between his subject matter and means of production, between language at face value and its myriad implications, and between hiding his hand and aspects of his autobiography and cultivating his status as art star and businessman. While his market and historical significance is still being debated, his legacy lives on through countless artists and the proliferation of licensed products bearing his image. His democratic fetishizing of everyday consumer items and his over-the-top cult of celebrity reach back to ancient idolatry worship, profoundly affecting how art is viewed today.

Life Savers, 1985, from the *Ads* series
Acrylic screenprint on canvas
38 × 38 inches
Loan courtesy Barbara Cuttriss

Radical
Alchemy

This chapter looks at artists who perform a secular transubstantiation through dislocation and suspension of disbelief. In their vision, sweets are turned into something else entirely or are referenced in a new context. Theirs is an alchemy that creates open-ended symbolic narratives. A cluster of Atomic Fireball candies, for instance, becomes a flower or symbol of life evoking earlier religious painting, in which still life objects carried allegorical significance, such as a white lily indicating the Virgin Mary.

Robert Watts, David Ireland, Al Hansen, and David Ottogalli set up secular rituals riffing on Dada and Futurism's revolutionary agendas and Marcel Duchamp's readymades. Watts makes life-size aluminum casts that serve as death masks and sells them in deli-style outlets or through a mail-order system, thereby subverting the notion of traditional art world commerce. Echoing the Greek concept of *xenia,* Ireland's *Concrete Sundaes* combine globs of concrete—a signature material that he fashions in a meditative practice—with "found" parfait glasses and spoons to give as presents to friends. The ritual aspect is even more apparent in Hansen's *Venus* collages, which use Hershey's wrappers and wordplay. He traces a lineage

through Joseph Beuys and stone fertility goddesses, suggesting that the divine can also be found in a discarded chocolate package. Ottogalli's humorous sculptures made out of marshmallow Peeps obliquely reference bloody Easter rituals of sacrifice and resurrection. While representing a latter-day version of the golden calf and its worshippers, they underline the relationship between manufactured sweets, commercial promotion, and special occasions.

Al Souza, Cecilie Dahl, and Yoshio Itagaki create a new context or perspective for understanding sweets. Combining chance, improvisation, and intellect, Souza rebuilds fragments of puzzles, themselves photographs of actual objects or persons, into kaleidoscopic images that seem to be in flux. With Dahl, chewing gum is transformed from a consumer item into an all-American symbol, a sexual catalyst, and, when stuck in hair, a terrifying image of entrapment and chaos. Itagaki also plays with brand recognition in his series of altered photographs featuring tourists sucking Popsicles or eating ice cream on the moon. Through the language of science fiction, he underscores the ubiquitous—even excessive—presence and pleasure that sweets carry as they reach new markets.

In their sculptures, Claire Lieberman, Tracy Heneberger, Susan Graham, and Charles Long emphasize the concrete reality and formal qualities of sweets to create highly abstract visual statements. Both Lieberman and Heneberger improvise with LifeSavers. Lieberman's alabaster and Jell-O simulacra emphasize survival, while Heneberger's glistening accumulation of rum butter LifeSavers taps the candy's reference to life and its growth potential. Graham fashions spun sugar into hundreds of miniature bed frames, arranging them in a spiral to suggest insomnia—a limbo between sleep and dream and, by extension, life and death. In Long's *Bubble Gum Station,* the work's biomorphic shapes echo the human body and establish an empathetic tie. As visitors listen to the sounds of Stereolab, they model pink, gumlike clay, a group activity that reinforces the idea of constant change and celebrates interconnectedness and creativity.

Cecilie Dahl

Born 1960, Oslo, Norway

Chewing gum as an all-American icon—this is the unlikely conceit that underlies Cecilie Dahl's many uses of the sticky, sweet-smelling material. As a commercial product, gum became linked to America after World War II, when it was included in the Marshall Plan ration packet. The gum was distributed to populations where U.S. forces were stationed, as well as included in the army's own ration packets; although ironically, gum comes from trees found in other parts of the globe. Beyond this national connection, chewing gum has immediate associations with American popular culture and kitsch.

The ideas of branding, cultural imperialism, and forced consumption fuel Dahl's gum-wrapper paintings, which cleverly recycle chewed gum back into its commercial packaging. The amount of gum required to achieve a thirty-by-twenty-four-inch expanse is considerable (although Dahl now buys gum in bulk, she initially braved puzzled looks at local drugstores when she purchased massive quantities of gum). As an activity, masticating in these quantities can be a form of madness or, conversely, meditation. The process of sweetness turning repugnant also comments on the pleasure principle, suggesting metaphorically what can happen to things we like to indulge in.

Other works focus on the oscillation between attraction and repulsion. One series of large-format color photographs explores two people negotiating a piece of gum. In close-up views of the gum being blown or tugged, the combination of fleshy open mouths and elastic material assumes marked sensual, even sexual, connotations. By contrast, the *Stuck* series revisits a childhood trauma: Forbidden to chew gum at home, Dahl's sister woke up one day at their grandfather's house with gum in her hair. The garish photographs of clotted webs entrapped in tangled strands conjure a nightmarish image akin to a Jackson Pollock drip painting.

Dahl's idea-driven explorations invite the viewer to rethink this humble material in ways never imagined. When we chew gum we don't swallow, and thus we don't digest anything. Yet perhaps, as recent scientific studies suggest, gum may have some benefits, including improving our ability to focus and remember.

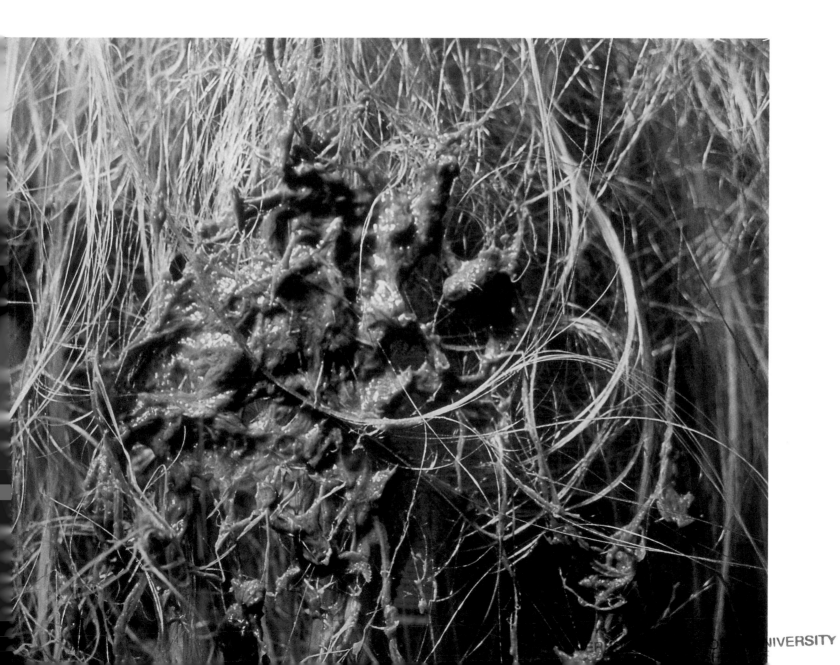

Stuck Green, 2001
C-print, sandwiched in plexi
19¼ × 27½ inches

Doublemint, 2001
Chewing gum on canvas
23 × 35½ inches

Spearmint, 2001
Chewing gum on canvas
23 × 35½ inches

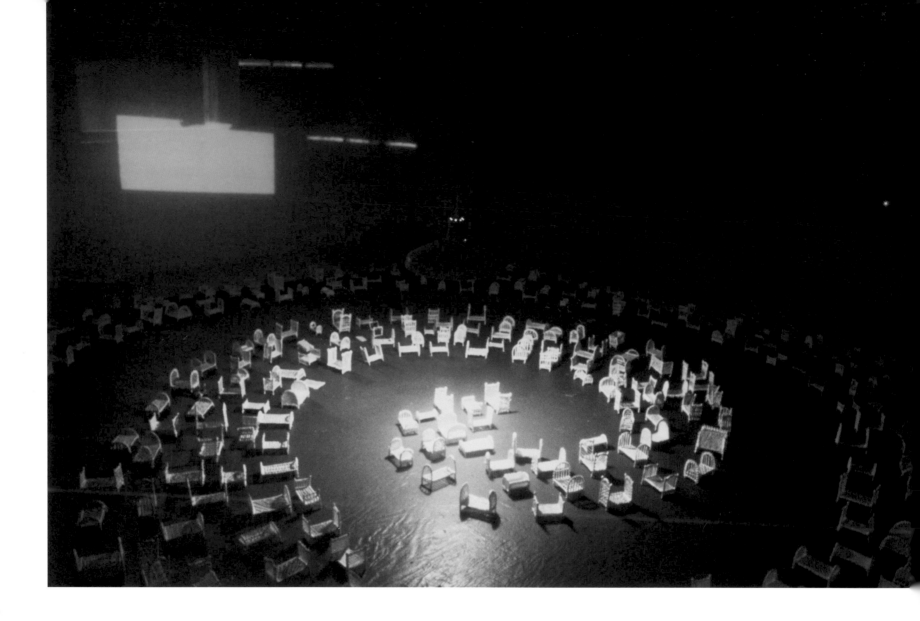

Susan Graham

Born 1968, Dayton, Ohio

Insomnia, 1999–2003
300-bed spiral of spun sugar and
egg whites
Dimensions vary, approximately
10 × 10 feet

Sweet-smelling *Insomnia* is a spiral of hundreds of miniature bed frames fashioned from spun sugar. When Susan Graham had trouble falling asleep in 1997, she came up with the idea of making the site of her discomfort—a bed—a work of art. While the labor-intensive activity of producing the beds reflects the open-ended, spinning mania of insomnia, the installation's vulnerability and otherworldliness echo the ephemeral nature of this condition. Each bed reflects a series of gestures, some intuitive and some planned, producing myriad variations on the prototype of the four-poster bed frame. Though crude, their elaborate filigree and warm white color conjure images of wedding cakes, lace, and other feminine objects.

When Graham moved to New York in 1991, she embraced the "bad girl" movement, which addressed rebellious attitudes, women's work, and nontraditional materials. An installation from 1995 explored the power of smell and food, featuring objects such as a pink cake and cherries decorated with beads and clothes in wire enclosures. A year later, inspired by her grandmother's craft classes, the artist started to experiment with the sculptural potential of spun sugar. She immediately liked the visceral response its smell triggered, and she began casting personal discards such as combs or other hygienic items.

More recently, Graham has sharpened her societal critiques with a series of spun sugar guns, whose sweetness effectively offsets the potential of such killing machines. In this context the substitution of spun sugar upsets our expectations of a gun's black, heavy metal qualities and its male associations. She is also investigating porcelain, another warm-colored material that, like sugar, is delicate and contains domestic overtones. A contemporaneously created photographic series, based on crude stagings, depicts dreamlike landscapes void of people, filled instead with beds or ladders. Delving deeply into our most primal zones, Graham's memorable imagery juxtaposes sweetness and beauty with ethereal states and, occasionally, disturbing activities.

Beuys Breast Venus, 1987
Mixed media
61 × 41 inches
Loan courtesy Bibbe Hansen

96

Al Hansen

Born 1927, Richmond Hills, New York
Died 1995, Cologne, Germany

An impresario extraordinaire, Al Hansen operated on the margins of the art world yet participated in two seminal movements of the late fifties and early sixties—Happenings and Fluxus. Both nonconformist movements sought to break down the barrier between art and life through temporary art-driven performances involving chance. The power of action as a means to plumb behavior and experience was paramount for Hansen. Exploring radically unconventional materials and subjects, he resisted the commodification of art. His Third Rail Gallery of Current Art, for instance, was open only when he staged Happenings, which were held at his home. In his view, the art object partakes in a continual cycle of loss and recovery of meaning, achieved through a sequence of actions the artist initiates. These actions could be performed simultaneously in different places, highlighting the temporal and fluid nature of a physical entity.

Throughout his protean career, Hansen pursued the theme of the goddess, leading him across time and culture to the fertility figures of prehistoric Europe. This endeavor also fostered a Zen-like approach to art making—the repetition of a simple act as a way to spontaneously discover the subject's essence. In the late fifties, an interest in advertising and a large collaged painting by Alan Kaprow inspired Hansen's well-known series using silver and brown Hershey's bar wrappers. *Beuys Breast Venus* is a raucous assemblage of text and shapes in the form of a voluptuous woman. Like a billboard, her body is covered with derivative words including "her," "she," "hey," and "yes." And to honor Joseph Beuys's pioneering use of organic materials and shamanistic view of the artist in society, Hansen inserts Beuys's name into the title, and superimposes Beuys's photographic portrait onto the figure's nurturing breasts.

From humble acts such as these, Hansen redeemed society's detritus, creating visual riddles that continue to defy pigeonholing and elude easy answers, instead opening new vistas of meaning.

Tracy Heneberger

Born 1954, New London, Connecticut

Tracy Heneberger transforms the most mundane and familiar objects—including nails, hinges, steel rings, and copper rods—into quixotic abstractions. Using the confines of a tightly controlled geometry, he builds obsessive multiples from small-scale industrial materials, achieving a dynamic tension between the effort of the hand and the ease of mass-production. His recent forays into the alluring and sensual world of candy add new layers of metaphor and meaning to his lyrical musings.

All of Heneberger's sculptures pulse with cellular growth. Emanating from a mysterious core, they suggest infinite expansion while conjuring a cornucopia of organic and architectural images. *Fire Lily,* a hexagonal accumulation of 162 Atomic Fireballs, bubbles with the promise of a blossoming flower. Its clear cement adhesive conjures the sensual activities of salivating and licking, an effect heightened by the candy's exotic cinnamon scent. The more baroque *Amber,* a horizontal sprawl of 535 rum butter LifeSavers—with its dazzling, multi-tiered rhythms hovering between symmetry and chaos—recalls aspects of a Persian miniature or the construction of Mayan buildings.

In recent years Heneberger has explored single casting during foundry residencies in China and the Japanese concept of *wabi,* the beauty of unfinished or imperfect things. *117 Lychees,* for example, began as nuts from fruit that the artist had consumed for lunch. After letting them dry on a roof in the sun, he sanded the ends flat and glued the spheres together into a tight, sinuous chain before casting them in bronze. The enigma of this piece is enhanced by the viewer's handling of it, which is what the artist intends; the object's pockmarked surface and sense of incompleteness suggest an exotic talisman or galactic rubble.

Heneberger's evolving aesthetic reflects a dual background in art and literature. Idiosyncratic amalgams of Dada and Surrealism, his sculptures create imaginative and dreamy enigmas out of found objects. At the same time, his use of mainstream, commercial materials dialogues with Pop iconography and language, and his rigorous formalism and ritualistic approach give his works a rich texture and look all their own.

Amber, 2002
Butterscotch LifeSavers
12 × 11 × 4 inches
Loan courtesy Gallery Paule Anglim,
San Francisco, CA

Fire Lily, 2000
Fireballs and cement
9 inches diameter × 4 inches deep
Loan courtesy Gallery Paule Anglim,
San Francisco, CA

David Ireland

Born 1930, Bellingham, Washington

A seminal figure in northern California, David Ireland is a sculptor of time and space who considers shape, history, and use when making art from the stuff of everyday life. A self-professed Conceptualist, his abiding aim is to break down the intellectual barrier that hinders the immediate and intuitive engagement with art.

Ireland came to art late, after first pursuing furniture design and world travel. Since the mid-seventies, his nineteenth-century San Francisco home on Capp Street has been the source of much artistic production, a kind of alchemical laboratory as well as a living environment. Whether reconfiguring the architecture of his house, modeling concrete, or arranging logs, he discovers and then subtly evokes the essence of what is already there. Crudeness and apparent carelessness are tools in his repertoire, as are verbal and visual puns, such as a pile of logs branded "I.D."—his own initials in reverse.

His *Dumb Balls*—concrete balls formed "mindlessly" by passing globs of moist concrete from hand to hand— represent a symbiotic, performative process between material and agent. Their original building function removed, they are free to offer instead musings on the meaning of perfection. Equally evocative are his *Concrete Sundaes*. On a gut level, the concrete's knobby texture against pressed glass and metal spoon triggers a visceral response. The image also induces a nostalgic reverie, conjuring memories of old-fashioned soda fountains. Conceptually, they bring to mind Yves Klein and Claes Oldenburg, while they also stand in for the artist himself, who began making the sundaes in the late nineties as gifts for friends.

Taking up Duchamp's idea that anything can be art by virtue of the artist's choice and the Surrealist notion of juxtaposing unlikely items to awaken consciousness, Ireland distinguishes himself by the degree of emotion and autobiography that permeate the humble poetry of his work. His interventions are Zen koans rather than intellectual exercises. They confound the boundary between art and life, showing us the potential for redeeming history and striking a balance between making one's mark and self-effacement.

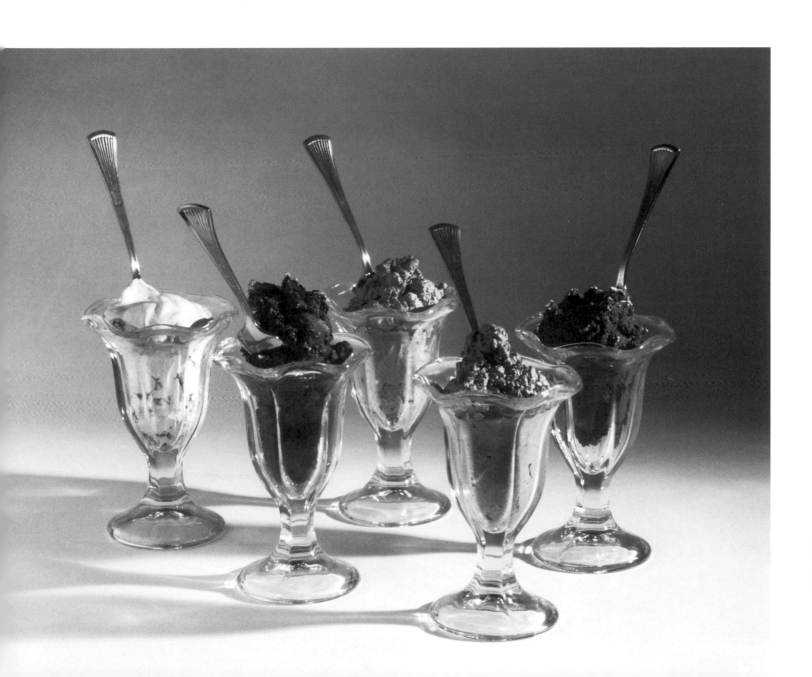

Concrete Sundaes, 1998–2001
Concrete, glass, metal, and pigment
10 × 6 × 4 inches each
Loan courtesy Gallery Paule Anglim,
San Francisco, CA and the artist

On the Einstein Beach, 2000
C-print
40 × 30 inches

Yoshio Itagaki

Born 1967, Nagoya, Japan

What could be more exotic than taking your vacation or honeymoon on the moon? How better to impress the friends back home than with a picture of you sucking a Popsicle in front of the Eiffel Tower, still under construction? In Yoshio Itagaki's darkly comic vision, tourism has moved beyond Earth, transforming his photographs into faded mementos from some distant point in time.

While traveling, Itagaki noticed how tourists from all backgrounds photograph monuments and one another, revealing a shared need for souvenirs. He began photographing other travelers, although they remained oblivious to his presence. Back in the studio, through skillful use of digital photography and computer montage, the artist transposed shots of tourists onto staged lunar beaches. With the Earth in the background as a recurring trope, signs of the so-called advance of consumer society and colonization are everywhere in evidence, from McDonald's and Nike trademarks to re-creations of Giza and Kyoto.

In *On the Einstein Beach,* a Lolita-style babe is happily sunbathing while enjoying Häagen-Dazs ice cream. Besides referencing an actual site, the photograph honors Einstein's revolutionary achievements in physics and astronomy as well as Philip Glass's opera *Einstein on the Beach.* Additional exoticism is provided by Häagen-Dazs itself. A poster child of American marketing, the product was invented by Reuben Mattus, who, after selling ice cream for thirty years, realized that Americans would pay more for this product if it had a foreign name.

In Itagaki's current series, tourists have even penetrated cyberspace and intermingle with computer game action figures. With humor and irony, he creates imaginary situations that appear entirely plausible. Giving new meaning to the familiar pastimes and sweet rewards of far-out tourist destinations, he reminds us of our insatiable appetite for newness and immortality.

Claire Lieberman

Born 1954, Milwaukee, Wisconsin

Taking on high modernism and its utopian mission is no easy task. Claire Lieberman's *Lifesavers* rises to the occasion by endowing distilled forms with suggestions of moral and spiritual truths. The piece juxtaposes two round, orange components with holes in their middles—one in alabaster, the other in Jell-O. The material of alabaster harkens back to classical notions of permanence and monumentality, while its sugary transparency links it to LifeSavers, objects with a much shorter shelf life. Jell-O, by contrast, is impermanent, fragile, and malleable to the touch. This archetypical nineteenth-century invention was offered to early-twentieth-century immigrants on Ellis Island as a welcome to America. Set inside a white Plexiglas box, Lieberman's paired objects seem to float on a pool of cool blue light.

Like the original LifeSavers—conceived in 1912 by a chocolate maker who wanted to formulate a sweet that would not melt—Lieberman's likenesses reference life buoys found at waterfronts or swimming pools and unleash a slew of associations. Wading through these layers of sensory experience leads to an appreciation of the contrasting qualities of the pair: old versus new, hard versus soft, handmade versus mass-produced, relatively permanent versus ephemeral. Yet each is unable to fulfill its intended function of life support.

In her other sculptures, videos, and photographic works, Lieberman uses Jell-O, alabaster, wax, and glass to question commonly held assumptions and expectations. Like *Lifesavers,* they trigger a sense of dislocation, probing arrested desire and touching on issues of survival and preservation. *Crystal Ice Guns,* for example, vividly revisits childhood fantasies, yet the fragility of the five glass weapons tempers the implicit violence. As in the case of *Lifesavers,* the sense of potential loss is rescued by the sheer beauty and sense of perfection of her compositions.

Lifesavers, 2001
Orange alabaster
11¾ diameter × 2½ inches height

Charles Long

Born 1958, Long Branch, New Jersey

Primal, palpable, and participatory, Charles Long's *Bubble Gum Station* offers an into-the-body-we-go antidote to our age of dematerialized information overload, where feeling is valued over thinking. Viewers are invited to sculpt pink clay bubblegum while listening over headsets to Stereolab's "How to Play Your Internal Organs Overnight" on a continuous loop. The British pop band echoes Long's neo-Futuristic look, coaxing ambient and socially conscious music out of outdated electronic equipment. Both activities encourage the possibility of strangers coming together to engage in a secular ritual to achieve a state of "no mind."

The eight other podlike works in *Amorphous Body Center* share this notion of connection and, similarly, straddle the languages of abstraction and figuration. With a nod to early Modernist formalism and Utopianism, Long's primal blobs and sinuous structures suggest basic yet nonspecific building blocks for living, filtered through a fifties and sixties sci-fi aesthetic and the revelatory vision of Stanley Kubrick.

Trained in ceramics, painting, performance, video, and installation, Long turned to sculpture, he says, to "work the psychology of objects and objectification." He has experimented with the notion of perpetual change by drawing Zen-like parallels between clay, a malleable, primeval material, and gum, a human-made substance that is chewed, discarded, or squished in the street. The artist also uses water, gel, air, and music as active ingredients in his work.

B.U.A. (Burnt Umber Assembly): An Entanglement of Wholes and Unity Purity Occasional More, a recent investigation of group dynamics, relates the idea of cleansing as a means of purification before social interaction. Other sculptures with nonmoving parts test viewers' responses from an opposite perspective. Will they realize that the perception of the body as a finite entity is a social construct and engage in the work with their imaginations? In all of his prophetic creations, Long explores a generous, trusting, and playful vision as he seeks a more harmonious and symbiotic relationship between body and mind.

Bubble Gum Station from *The Amorphous Body Study Center*, 1995
Modeling clay, sound equipment, stools and table
94 × 89 inches
Loan courtesy Collection Museum of Contemporary Art, Chicago; gift of Susan and Lewis Manilow

David Ottogalli

Born 1964, Cleveland, Ohio

Forget Easter! Legions of marshmallow chick and rabbit Peeps in vibrant colors move beyond their traditional association with holidays, joining ranks to peer out playfully from a Kentucky Fried Chicken bucket, escape the confines of a chicken coop to proudly form an American flag, or even ascend into an exotic shrine dedicated to sugary goodness.

David Ottogalli is obsessed with artificially colored food. As a little boy he dyed his milk red and had his birthday cakes colored green or orange or transformed into black-and-white checkerboards. In the early nineties he began making art out of Peeps, macaroni, peanuts, Fruit Loops, and other food items. While his cereal-based works retain their sickly artificial colors, many of his Peeps, macaroni, and bread creations experiment with Day-Glo spray paints. Some configurations feature contrasting fluorescent rows or rainbows; others spiral out from the center. Like Andy Warhol's silkscreens, Ottogalli's Peeps compositions exploit the myriad differences in what, at first glance, seem to be monotonously repetitive mass-produced items. Some Peeps are plumper than others; others' eyes are askew or ears are bent. Breaking all the rules of good taste—and tasting good—they mesmerize even as they elicit passionate craving or revulsion from viewers.

Rather than signaling the demise of culture, Ottogalli's extravagant displays of edible bliss recognize that most people will purchase and eat whatever manufacturers make and sell. With a whimsical sense of perfection, this self-taught artist has created an entire cosmology out of Peeps, turning them into all-American icons for aesthetic delectation and worship.

Peeps McNuggets
McDonald's Chicken McNugget containers,
Marshmallow Peeps, spray paint
48 × 48 inches

Rainbow Bunnies
Marshmallow Bunnies, spray paint, canvas
24 × 36 inches

Peeps Spangled Banner
Marshmallow Peeps, Marshmallow Bunnies,
canvas
36 × 48 inches

Al Souza

Born 1944, Plymouth, Massachusetts

Good 'n' Plenty, detail, 2000
Puzzle parts and glue on wood
72 × 84 inches
Loan courtesy Charles Cowles Gallery,
New York, NY

A kaleidoscope of food, people, sports, flowers, and landscapes blasts out from Al Souza's works, which are composed of thousands of interlocking and layered jigsaw puzzle pieces. This engineered use of puzzles perfectly expresses this artist's delight in unconventional materials and alternate methods of making art. As a student in aerial engineering, Souza focused on deconstructing mechanical objects in the laboratory and creating something original and offbeat. Later, when he began making art, this instinct led him to create work that was anything but traditional or fashionable.

Souza is attracted to the tactile connection with everyday life that making jigsaw puzzles provide. He searches thrift shops or the eBay website for second-hand puzzles that are based on photographs of real subjects and not paintings, further compounding the play between artifice and reality, and between art and life. Then in his studio he works with multiples of the same puzzle, and adjusts loose pieces and clumps of pieces until the colliding micro universes of color and content deliver the desired effect yet appear in perpetual motion.

Equally as curious are his spitballs, which like his other work, function both on a representational and abstract level. A tribute to David Ireland's *Dumb Balls,* Souza's spheres, gummed together out of his saliva and *The New York Times,* involve a similar obsessive ritual that yields meditative fulfillment (13,000 balls emerged from two weeks worth of newspapers). He has also cut away ellipses of various sizes from sheets of comics, maps, wallpaper, and numeric charts exposing random, peek-a-boo encounters.

The use of inexpensive, non-traditional materials and a visceral hands-on approach that intermingles intellect, chance, and accident link Souza to John Cage, Fluxus experiments of the early 1960s, and the Arte Povera movement. Making sense out of nonsense, Souza's collages frequently comment on our obsessively driven consumer culture, even as they provoke us to regard our often-overlooked, familiar surroundings with renewed wonder. Like a treasure hunt or a detective story, their myriad spatial and logical jumps stimulate ongoing discoveries, letting viewers determine the significance of his pieces for themselves.

Chocolate Cream Pie, 1964
Aluminum
2½ × 5 × 5 inches
Courtesy Jane Voorhees Zimmerli Art
Museum, Rutgers, The State University
of New Jersey. Gift of Bernard and
Florence Galkin

Robert Watts

Born 1923, Burlington, Iowa
Died 1988, Bangor, Pennsylvania

In the late fifties and early sixties Robert Watts and a tight group of associates were challenging the definition and look of art in ways that few, if any, could anticipate. Drawing on early-twentieth-century movements such as Dada, Surrealism, and Futurism, Watts was also involved with early Pop developments and Fluxus, the international movement whose goal was to get rid of antiquated art forms and ignite a sociopolitical revolution.

After some early paintings in the Abstract Expressionist mode, he tapped into his training in mechanical engineering and began creating sculpture that experimented with Christmas tree lights and items of everyday life. Soon he promoted, in his own words, "time-space-movement situations," multimedia events that incorporated electromechanical devices and exposed the interdependence between object and observer. As a teacher at the Douglass campus of Rutgers University, he collaborated with colleagues and students on various, far-reaching projects and performances, including the May 1963 Yam Festival held at George Segal's farm (Yam is May spelled backward).

By the early sixties, Watts had subverted the mail delivery system through his "borrowed" mailboxes. This activity involved substituting self-designed stamps into government dispensers and encouraging the public to purchase and use them illegally as postage. He also explored conventional wisdoms surrounding food consumption by casting and plating in metal actual eggs, bread, butter, TV dinners, and sweets. Sold through a mail-order system or in a delicatessen-style show, these loaded fetishes overturned traditional mechanisms for the marketing and selling of art. At the same time they acted as memento mori, allowing viewers to see their own reflections and slyly reminding them of their own mortality.

From his *Monument* series of found objects and text embedded in plaster to his counterfeit dollar bill projects, from his series of mechanical toys to his appropriated artist signatures in neon, Watts predicted ideas that have since flourished. Equally as important, his sense of generosity and radical notions about the distribution of art continue to inform the relationship between artist and audience.

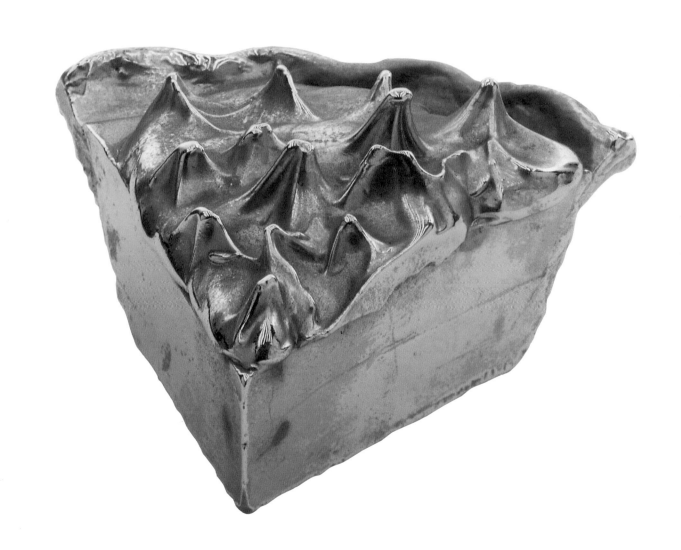

Coda

In its myriad manifestations, the theme of *Sweet Tooth* engages our senses and touches our deepest passions. While our familiarity with candy often masks its mystical potential, for certain artists stepping on gum or finding a wrapper can trigger an aesthetic epiphany and inspire a work that mirrors our inner selves.

As a metaphor, the phenomenon of sweetness echoes transcendental religious experience. Both the Hindus and the Sikhs speak of a sweet physical substance, *amrit,* which the body secretes in an enlightened state and which the alchemists of Europe termed the elixir of life. Similarly, the artists in *Sweet Tooth* grace sweetness, giving life to otherwise mute forms. From the sensuous to the erotic to the ecstatic, they evoke the pristine stage of early infancy, a Garden of Eden where abundance reigns and eating occurs without guilt or responsibility. Yet, as self-aware twenty-first-century consumers, we recognize the illusion of such un-limited supply.

Still lifes with sweets can reconcile this gap between the physical and the divine. Just as the fugitive nature of their subject is part of an ongoing organic cycle, in freezing time the works also represent a quest for immortality. Taken together, the wondrous spectacles and constructed fictions in *Sweet Tooth* suggest a threshold, offering a fresh appreciation of life in the face of an uncertain yet hopefully sweet future.

Selected Bibliography

Coe, Sophie D. and Michael D. *The True History of Chocolate*. London: Thames & Hudson Ltd., 1996.

Elesby, Sally and Anne Ayers. *In the Polka Dot Kitchen*. Pasadena, CA: Pasadena Art Alliance, 1998.

Langmuir, Erika. *Still Life*. London: National Gallery Company Limited, 2001.

Lawrence, Jeremy. "Gum Chewing Found to Boost Brainpower, Memory." *Reuters*, March 13, 2002.

Lieberman, Claire. "That Food Thing You Do." *Sculpture*, December 2000: pp. 46–49.

Maka, Tanja. *Eat Art: Joseph Beuys, Dieter Roth, Sonja Alhäuser*. Cambridge, MA. Harvard University Art Museums Gallery Series (no. 33), 2001.

Pierce, Paul. *Novel Suggestions for Social Occasions*. New York: Barse & Hopkins, 1907.

Rowell, Margit. *Objects of Desire: The Modern Still Life*. New York: Harry N. Abrams, 1997.

Sheets, Hilarie M. "The Oranges Are Alive." *ARTnews*, March 2000: pp. 118–120.

Slive, Seymour. *Dutch Painting 1600-1800*. New Haven and London: Yale University Press, 1995.

Steingarten, Jeffrey. "Chocolate Fantasy." *Vogue*, February 2001: pp. 286–309.

Weil, Dr. Andrew and Winifred Rosen. *From Chocolate to Morphine*. Boston/New York: Houghton Mifflin Company, 1983.

Checklist of the Exhibition

Meredith Allen
Atlantic Avenue (bugs bunny), 2000
C-print; 18 × 22 inches
Loan courtesy Gracie Mansion Gallery,
New York, NY
page 37

Atlantic Avenue (spongebob), 2001
C-print; 18 × 22 inches
Loan courtesy Gracie Mansion Gallery,
New York, NY
page 39

Moriches Island Road (supersonic), 2000
C-print; 18 × 22 inches
Loan courtesy Gracie Mansion Gallery,
New York, NY
page 38

Peter Anton
Monarch Assortment, 2000
Mixed media; 48 × 36 × 10 inches
Loan courtesy Gracie Mansion Gallery,
New York, NY
page 13

Robert Arneson
Blueberry Pie N°9, 1971
Earthenware; 9 × 19½ × 5½ inches
Loan courtesy Norma Schlesinger
cover, page 62

Shimon Attie
White Night, Sugar Dreams N°2, 2000
Chromogenic print; 30 × 30 inches
Loan courtesy Gallery Paule Anglim,
San Francisco, CA and the artist

White Night, Sugar Dreams N°4, 2000
Chromogenic print; 30 × 38 inches
Loan courtesy Gallery Paule Anglim,
San Francisco, CA and the artist
page 41

White Night, Sugar Dreams N°3, 2000
Chromogenic print; 30 × 40 inches
Loan courtesy Gallery Paule Anglim,
San Francisco, CA and the artist
page 40

Barton Lidice Benes
Petits Fours, 2001
AIDS pills, paper, and glass; lid: 12 inches
diameter; stand and lid: 12 inches height
Loan courtesy Lennon, Weinberg, Inc.,
New York, NY
pages 2–3 (detail), 42

Sampler, 2002
Shredded money; 11 × 13½ × 1½ inches
Loan courtesy Lennon, Weinberg, Inc.,
New York, NY
pages 32 (detail), 42

Alexandra Blau
Choco, 2001
Acrylic on linen; 12½ × 12½ inches
pages 8 (detail), 14

Fruit Stripe, 2002
Acrylic on linen; 12½ × 12½ inches
Loan courtesy Mark Moore Gallery,
Santa Monica, CA
page 14

Watermelon, 2002
Acrylic on linen; 12½ × 12½ inches

Rebeca Bollinger
boy, 1997
Cookies, shrink wrap, cardboard;
18 × 14 × ¾ inches
Loan courtesy Rena Bransten Gallery,
San Francisco, CA

girl, 1997
Cookies, shrink wrap, cardboard;
18 × 14 × ¾ inches
Loan courtesy Rena Bransten Gallery,
San Francisco, CA

untitled (baby), 1997
Cookies, shrink wrap, cardboard;
13 × 10 × ¾ inches
Loan courtesy Rena Bransten Gallery,
San Francisco, CA
page 45

untitled (nillas), 1997
Cookies, shrink wrap, cardboard;
9 × 15 × 1 inches
Loan courtesy Rena Bransten Gallery,
San Francisco, CA
page 45

Enrique Chagoya
Mr. Sugar Comes to Town, 1989
Graphite and colored pencils;
10 × 9½ inches
Cover, pages 11, 19, 29
Published by Children's Book Press,
San Francisco, CA
page 46

Robert Colescott
Le Cubisme: Chocolate Cake, 1981
Acrylic on canvas; 84 × 72 inches
Loan courtesy Phyllis Kind Gallery,
New York, NY
pages 58 (detail), 64

Will Cotton
Abandoned (Churro Cabin), 2002
Oil on linen; 60 × 60 inches
Loan courtesy Mary Boone Gallery,
New York, NY
page 16 (detail)

Cecilie Dahl
Doublemint, 2001
Chewing gum on canvas; 23 × 35½ inches
page 92

Spearmint, 2001
Chewing gum on canvas; 23 × 35½ inches
page 93

Stuck Green, 2001
C-print, sandwiched in plexi; 19¼ ×
27½ inches
page 91

Stuck Yellow, 2001
C-print, sandwiched in plexi; 27½ ×
19¼ inches

Emily Eveleth
Approach, 1998
Oil on canvas; 60 × 66 inches
Private Collection; courtesy Danese
Gallery, New York, NY
page 19

Bruno Fazzolari
Leibniz, 1998–2000
Plaster, oil paint; 961 pieces, 62 × 77 inches
Loan courtesy Debs & Co., New York, NY
page 20

Susan Graham
Insomnia, 1999–2003
300-bed spiral of spun sugar and
egg whites; dimensions vary, approxi-
mately 10 × 10 feet
page 94

Matt Gray
Untitled (N°3920, Stupid Candy series),
2000
C-print; 20 × 24 inches
Loan courtesy Richard Levy Gallery,
Albuquerque, NM
page 23

Untitled (N°3925, Stupid Candy series),
2000
C-print; 20 × 24 inches
Loan courtesy Richard Levy Gallery,
Albuquerque, NM
page 25

Untitled (N°3867, Stupid Candy series),
2000
C-print; 20 × 24 inches
Loan courtesy Richard Levy Gallery,
Albuquerque, NM

Untitled (N°4301, Stupid Candy series),
2001
C-print; 20 × 24 inches
Loan courtesy Richard Levy Gallery,
Albuquerque, NM
page 24

Al Hansen
Beuys Breast Venus, 1987
Mixed media; 61 × 41 inches
Loan courtesy Bibbe Hansen
page 96

Tracy Heneberger
Amber, 2002
Butterscotch LifeSavers; 12 × 11 × 4 inches
Loan courtesy Gallery Paule Anglim,
San Francisco, CA
page 99

Fire Lily, 2000
Fireballs and cement; 9 inches diameter ×
4 inches deep
Loan courtesy Gallery Paule Anglim,
San Francisco, CA
pages 86 (detail), 99

Mildred Howard
*Post-Traumatic Slave Syndrome: Don't
Get it Twisted, This is Not My Real Life*,
2001
Hand-sewn silk with photo transfers
in handmade box; 8 × 9 × 2 inches
Loan courtesy Tupac Amaru Shakur
Foundation
pages 50, 51 (detail)

*Post-Traumatic Slave Syndrome:
To the Bone*, 2001
Resin, bones, teeth, cellophane wrappers
in handmade silk box; 10 × 5 × 2 inches
Loan courtesy Gallery Paule Anglim,
San Francisco, CA and the artist
page 49

David Ireland
Concrete Sundaes, 1998–2001
Concrete, glass, metal, and pigment;
10 × 6 × 4 inches each
Loan courtesy Gallery Paule Anglim,
San Francisco, CA and the artist
page 101

Yoshio Itagaki
On the Einstein Beach, 2000
C-print; 40 × 30 inches
page 102

Honeymoon—New Paris, 1999
C-print; 30 × 40 inches

Julia Jacquette
If Only You Thought, 1994
Enamel on wood; 11 panels, each
8 × 8 inches
Loan courtesy Jean Yves Noblet
pages 5, 67

Paul Kittelson
Powder, 1998–2002
Hydrocal, wire, and Styrofoam;
92 × 90 × 36 inches
page 68

Charlotte Kruk
Diva, Diva, GODIVA, 2002
Godiva Chocolates

Her, She Says Kisses, 1996
Hershey's candy bar and Kisses
wrappers
page 71

*"She Said, 'These are Good, But You've
Had Plenty,'"* 1996
Recycled Good & Plenty boxes, size 8
page 71

Claire Lieberman
Lifesavers, 2001
Orange alabaster; 11¾ diameter ×
2½ inches height
page 104

Lifesavers, 2001
Jell-O; 11¾ diameter × 2½ inches height

Angela Lim
Sweet Domain: Bananas Flambe, 1996
Mixed media with hand embroidery,
4 × 2½ inches diameter
Loan courtesy Catharine Clark Gallery,
San Francisco, CA
page 72

Sweet Domain: Blossom Brulee, 1996
Mixed media with hand embroidery;
1¾ × 5 × 3½ inches
Loan courtesy Catharine Clark Gallery,
San Francisco, CA
page 72

Sweet Domain: Blushing Bombe, 1996
Mixed media with hand embroidery;
6½ × 8½ inches diameter
Loan courtesy Catharine Clark Gallery,
San Francisco, CA

Sweet Domain: Deep Dish Dormant Pie,
1996
Mixed media with hand embroidery;
4 × 9 inches diameter
Loan courtesy Catharine Clark Gallery,
San Francisco, CA

*Sweet Domain: Dreary-go-round
Ganache*, 1996
Mixed media with hand embroidery;
3½ × 4 inches diameter
Loan courtesy Catharine Clark Gallery,
San Francisco, CA
page 72

Sweet Domain: Perfect Role Profiteroles,
1996
Mixed media with hand embroidery;
6½ × 8½ inches diameter; 3 × 5½ inches
diameter
Loan courtesy Catharine Clark Gallery,
San Francisco, CA

Sweet Domain: Slivered Peach Torte, 1996
Mixed media with hand embroidery;
3 × 9 × 9 inches
Loan courtesy Catharine Clark Gallery,
San Francisco, CA

Sweet Domain: Sweet Rum Rockers, 1996
Mixed media with hand embroidery;
2 × 5½ inches diameter
Loan courtesy Catharine Clark Gallery,
San Francisco, CA
page 72

Charles Long
Bubble Gum Station from *The Amorphous
Body Study Center*, 1995
Modeling clay, sound equipment, stools
and table; 94 × 89 inches
Loan courtesy Collection Museum of
Contemporary Art, Chicago; gift of
Susan and Lewis Manilow
page 107

Vik Muniz
Raft of the Medusa, 1999
Silver dye bleach print (Ilfochrome);
Two parts: 90 × 120 inches
Loan courtesy Ronald W. Garrity
pages 35 (detail), 52

Claes Oldenburg
Profiterole, 1989
Cast aluminum, latex paint, and brass;
6 × 6½ × 8¾ inches
Loan courtesy Claes Oldenburg and
Gemini G.E.L., Los Angeles, CA
page 74

Profiterole, 1990
Lithograph; 31¼ × 41 inches
Loan courtesy Gemini G.E.L.,
Los Angeles, CA
page 74

David Ottogalli
Site-specific installation

Mary Curtis Ratcliff
Homage to Barbara Bush, 1998
Steel, plaster, acrylic, and mixed media;
50½ × 19 × 19 inches
page 77

Homage to Liberace, 1996
Steel, plaster, acrylic, and mixed media;
18½ × 10¾ × 10¾ inches

*Jane Austen Cake ("If You Cannot Think of
Anything Appropriate to Say")*, 1996
Steel, plaster, and acrylic; 5¼ × 14 ×
14 inches
page 77

Ed Ruscha
Babycakes with Weights (New York:
Multiples, Inc., 1970), 1970
Cover of 52-page book with 22 b&w
offset prints; 7½ × 6¼ inches closed
Loan courtesy Fine Arts Museums of
San Francisco/Achenbach Foundation
for Graphic Arts, Museum Purchase,
Reva and David Logan Collection
of Illustrated Books, Reva and David
Logan Fund, 2001.64.2.1–22
page 27

Mews, from the portfolio *News, Mews,
Pews, Brews, Stews & Dues*, 1970
Color screenprint printed with
Bolognese sauce, black currant pie
filling and raw egg, E. 35; 23 × 31 inches
Loan courtesy Fine Arts Museums of
San Francisco/Achenbach Foundation

News, from the portfolio *News, Mews,
Pews, Brews, Stews & Dues*, 1970
Color screenprint printed with black
currant pie filling and red salmon roe,
E. 34; 25 × 31 inches
Loan courtesy Fine Arts Museums of
San Francisco/Achenbach Foundation
for Graphic Arts, Museum Purchase,
Mrs. Paul L. Wattis Fund, 2000.131.34.1
page 27

Pews, from the portfolio *News, Mews,
Pews, Brews, Stews & Dues*, 1970
Color screenprint printed with Hershey's
chocolate-flavor syrup, Camp coffee,
chicory essence, and squid ink, E. 36;
23 × 31 inches
Loan courtesy Fine Arts Museums of
San Francisco/Achenbach Foundation

Proof for *Sweets, Meats, Sheets*, from
the *Tropical Fish* series, 1975
Color screenprint, E. 83; 32¾ ×
25¾ inches
Loan courtesy Fine Arts Museums of
San Francisco/Achenbach Foundation
for Graphic Arts, Museum Purchase,
Mrs. Paul L. Wattis Fund, 2000.131.72
page 26

Laurie Simmons
Alles Liebe (Vanilla), 1990
Cibachrome photograph; 23 × 35 inches
Loan courtesy A.G. Rosen
page 79

Sandy Skoglund
Shimmering Madness, 1998
Cibachrome photograph; 36 × 46 inches
Loan courtesy The Collection of Dale &
Doug Anderson
pages 61 (detail), 80

The Wedding, 1994
Cibachrome photograph, 38½ × 48 inches
Loan courtesy Janet Borden Gallery,
New York, NY
pages 82 (detail), 83

Al Souza
Good 'n' Plenty, 2000
Puzzle parts and glue on wood; 72 ×
84 inches
Loan courtesy Charles Cowles Gallery,
New York, NY
page 110 (detail)

Jana Sterbak
Catacombs, 1992
Chocolate; dimensions variable
Loan courtesy Donald Young Gallery,
Chicago, IL
page 55

Wayne Thiebaud
Dessert Circle, 1992–1994
Oil on panel; 21 × 19 inches
Loan courtesy Betty Jean Thiebaud
pages 11 (detail), 29

Two Heart Cakes, 1994
Oil on linen; 28 × 22 inches
Loan courtesy LeBaron's Fine Art,
Sacramento, CA
page 29

Ted Victoria
Let's Eat Inside, 2001
Projected installation with food and
live Sea-Monkeys; 3 towers, each 8 ×
20 × 20 inches
page 56

Andy Warhol
Life Savers, 1985, from the *Ads* series
Acrylic screenprint on canvas; 38 ×
38 inches
Loan courtesy Barbara Cuttriss
page 85

Robert Watts
Chocolate Cream Pie, 1964
Aluminum; 2½ × 5 × 5 inches
Courtesy Jane Voorhees Zimmerli Art
Museum, Rutgers, The State University
of New Jersey. Gift of Bernard and
Florence Galkin
back cover, page 113

Meg Webster
Molasses, 2002
Molasses on paper; 60 × 60 inches
Loan courtesy Paula Cooper Gallery,
New York, NY
page 31

Photo Credits and Permissions
Robert Colescott, pages 58 (detail), 64
Photo: Adam Reich

Andy Warhol, page 85
© 2002 Andy Warhol Foundation for
the Visual Arts/Artists Rights Society
(ARS), New York

Bit-o-Honey, Betty Crocker, Chiclets,
Day-Glo, Godiva, Good & Plenty,
Häagen-Dazs, Hershey's, Jell-O,
Kentucky Fried Chicken, LifeSavers,
McNuggets, and Peeps are all regis-
tered trademarks.

Unless otherwise noted, all images are
courtesy of and copyright of the artists.

I am deeply indebted to all the artists, dealers, and collectors who have generously shared their insights and works, helping to make this exhibition such a broad treatment of the subject. I owe special thanks to the enthusiastic staff at COPIA. In particular, I would like to recognize the energy and expertise of Neil Harvey, Doreen Schmid, Betty Teller, Deborah Gangwer, and the vision of its director, Peggy Loar. Most of all, I am forever grateful to my husband, Lucian Perkins, for the care and support he has shown throughout the project, and to my parents for encouraging me to pursue my dreams. And lastly, I tip my hat to all those out there who enjoy sweets and inspired the initial idea for the exhibition.

Sarah Tanguy
Exhibition Curator

Acknowledgments

Any exhibition of this size demands the efforts, and commitment, of a large number of individuals. We at COPIA would like to thank the many galleries, lenders, and artists, listed in the checklist, whose generous loans made the organization of *Sweet Tooth* possible.

This exhibition was enriched by the skilled and imaginative exhibition design of Bill White and the graphic design of Connie King. Registrar Neil Harvey, assistant registrar Genevieve Sun, exhibitions manager Deborah Gangwer, and preparator Stan Hitchcock expertly guided and supervised the exhibition's design and installation. As always, our department administrator Ann Hitchcock approached each new task and deadline with willingness and capability. This book reflects the sensitive and thoughtful editing of publications manager Doreen Schmid, who ably directed the development of this catalogue. We are indebted to Marquand Books for their fresh and creative design approach and their expert handling of all aspects of this book's production; in particular, thanks to Ed Marquand, Jeff Wincapaw, and Marie Weiler. COPIA's programs department, under the direction of Daphne Derven, has responded to the theme of *Sweet Tooth* with imaginative and thoughtful programs.

We thank all of the artists featured for their enthusiastic participation and for their allowing us to feature work of such quality and imagination. Above all, we must express enormous gratitude to guest curator Sarah Tanguy, who proposed this exhibition to us three years ago. She has brought her considerable talents and energy to bear on this production in extraordinary proportions.

Betty Teller
Assistant Director for Exhibitions

About
the Curator

Sarah Tanguy is an independent curator and critic based in Washington, D.C. Besides *Sweet Tooth*, her recent projects include *Off the Press: Recontextualizing the Newspaper in Contemporary Art*, and an ongoing exhibition series for the American Center for Physics. Since 1983 Tanguy has developed over a hundred exhibitions, including the *Tools As Art* series at the National Building Museum in Washington, D.C., projects for the Alternative Museum in New York, and a traveling exhibition from the Hechinger Collection. Other highlights are *The View from Here*, an exhibition that premiered at the State Tretyachov Gallery in Moscow and will tour in Russia and the United States; *Landshapes* at the Southeast Museum of Photography in Daytona Beach, Florida; *New Angles: Photographs by Andre Chezhin* and James Mahoney's *House of the World* at the District of Columbia Arts Center; and several outdoor and indoor sculpture exhibitions in downtown Washington, D.C. In addition to numerous exhibition-related essays, she has written for the *Washington Times, Sculpture, New Art Examiner, Glass, American Craft, Hand Print Workshop International, Turning Points, Mid-Atlantic Country*, and *Baltimore*.

The daughter of a retired diplomat, Tanguy was born in Penang, Malaysia, in 1955. She has a B.A. in fine arts from Georgetown University (1978). After receiving an M.A. in art history from the University of North Carolina, Chapel Hill, she returned to Washington, D.C., in 1983 as an intern at the Hirshhorn Museum and Sculpture Garden. She has since worked at the National Gallery, the International Exhibitions Foundation, the Tremaine Collection, the International Sculpture Center, the Smithsonian Institution Traveling Exhibition Service, and the Hechinger Collection.